EGMONT KEY

EGMONT KEY

A HISTORY

To Emma, Enjoy this story of Egmont Key's past.

3/1/14

Donald H. Thompson

**DONALD H. THOMPSON
& CAROL THOMPSON**

Carol L. Thompson

Charleston · London

THE
History
PRESS

Published by The History Press
Charleston, SC 29403
www.historypress.net

Front cover lighthouse image courtesy of Roberta Moore Cole.
Bottom image courtesy of Robert English.
Back cover top image courtesy of the authors. Bottom image courtesy of
Roberta Moore Cole.

First published 2012
Second printing 2013

Manufactured in the United States

ISBN 978.1.60949.708.8

Library of Congress CIP data applied for.

Notice: The information in this book is true and complete to the best of our knowledge. It is offered without guarantee on the part of the authors or The History Press. The authors and The History Press disclaim all liability in connection with the use of this book.

CONTENTS

ACKNOWLEDGEMENTS

Over the course of the several years this book has been in progress, many people have provided help, whether through interviews, lending photos, sharing their areas of expertise, facilitating the research or assisting in many other ways. We would like to recognize two individuals in particular, both of whom sadly have passed away before seeing the book's completion and who were invaluable in making the book accurate and (we hope) interesting to readers.

We had the good fortune to meet the late Roberta Moore Cole some years ago. She was the granddaughter of Egmont Key lighthouse keeper Charles Moore, and her father, Charlie Moore, was in charge of building Fort Dade. Roberta Moore Cole spent the first ten years of her life on the island. Her stories of life on Egmont Key were an inspiration in writing this book. She generously shared memories and experiences and loaned us many photos that appear in the book. Regrettably, she passed away just shy of her 100th birthday, before the book was finished.

The other special person is Phil Sorenson, a fellow member of the Egmont Key Alliance, who passed away in February 2012. Phil was a dedicated and hardworking volunteer for several conservation organizations, and he was very knowledgeable about the plants and wildlife on Egmont Key. In the spring of 2011, he and Don walked around the island, and Phil identified and described the various plants and trees that grow there. His willingness to help and share his expertise was very much appreciated, and he is greatly missed.

ACKNOWLEDGEMENTS

In addition to these two individuals, we would like to thank the following people for their help. Their contributions are gratefully recognized and appreciated. Please accept our apologies if we have neglected to include someone on this list:

Wendy Anastasiou
Valerie Bell
Bill Burger
Melissa Buhler
Carrie Caignet
Chris Cargo
Kent Chitlain
Genny Donaldson
David Ekardt
Barbara Fite
Pamela Gibson
Judy Hildman
Evelyn Hoskins
Barbara Howard
Brenda Humphries
Neil Hurley
Jim Igler
Richard Johnson

Kathy Keleher
Joyce Klein
Ross Lamoreaux
Paul Lien
Sandie Mallett
Barbara McBath
John McDonald
Geoffrey Mohlman
Richard Sanchez
John and Barbara Schmidt
John C. Timmel
Andrew Thompson
Herman Trapmann
Libby Warner
Tom Watson
Nancy Whitford
Melissa Williams

In addition we would like to thank the staff at the following libraries and museums: Anna Maria Island Historical Society, Dade Battlefield State Historic Site, Florida Aquarium of Tampa, Florida Maritime Museum of Cortez, Fort De Soto Museum, Fort Foster State Park, Gamble Plantation Mansion Historic Site, Gulf Beaches Historical Museum, Henry B. Plant Museum, Hernando De Soto National Memorial Park, John F. Germany Library in Tampa, Manatee County Central Library, Bradenton, Mote Aquarium, Port Tampa City Library, St. Petersburg Central Library, South Florida Museum and Tampa Bay History Center.

EGMONT KEY CHRONOLOGY

7,500 BC	Gulf of Mexico nears present level
1,000–700 BC	Tocobaga Indians create shell mounds
1539	Hernando de Soto arrives at Tampa Bay
1757	Don Francisco Maria Celi surveys island, erects cross and names it Isla de Cruz
1763	England gains control of island and surveyor George Gould calls it Egmont Key
1783	Spain regains control of Florida
1816–1858	Three Seminole wars occur
1819	Adams-Onis Treaty makes Florida part of U.S.
1824	Fort Brooke is built in Tampa
1828	Indian Removal Act passes and army builds stockade on Egmont Key
1831	Lt. Robert E. Lee suggests fortification of Egmont Key

1835	Dade Massacre starts Second Seminole War
1842	Armed Occupation Act gives settlers 160-acre plots of land
1845	Florida becomes 27th U.S. state
1848	First lighthouse built on Egmont Key; later destroyed by hurricane
1858	Last Seminoles leave Egmont Key for Oklahoma; second lighthouse completed
1861	Lighthouse lens removed by Confederates; Union takes control of Egmont Key
1863	Union forces destroy Confederate blockade runners *Kate Dale* and *Scottish Chief*
1864	Yellow fever epidemic occurs; marine hospital and cemetery established on island
1865	Lighthouse keeper helps Confederate secretary of state Judah Benjamin escape
1878–1910	Captain Charles Moore serves as Egmont Key lighthouse keeper
1880s	Excursion steamers begin stopping at Egmont Key
1888	Tampa Bay Pilots Association formed
1898	Sinking of Battleship *Maine* starts Spanish-American War
	Egmont Key becomes part of coastal defense
	Charlie Moore becomes supervisor for construction of Fort Dade
	Quarantine station for returning soldiers set up on island

EGMONT KEY CHRONOLOGY

1910	Five gun batteries exist at Fort Dade
1912	Tampa Bay Pilots Association leases land on south end of island
1920s–30s	Fires and hurricanes destroy buildings of Fort Dade
1921	Fort Dade deactivated
1923	All personnel except caretaker leave Fort Dade
1931	Fort Dade and Fort De Soto up for sale for $387,000
1939	Coast Guard assumes responsibility for lighthouse operation
1941	Troop training for World War II begins on Egmont Key
1947	Old lantern room removed; automatic electric beacon installed in lighthouse
1950s	Assistant lighthouse keeper's house replaced with cement Coast Guard building
1970s	Brazilian pepper plants and Australian pine invade island
	Erosion begins to undermine Batteries Burchsted and Page
1974	Egmont Key becomes a National Wildlife Refuge
1978	Egmont Key named to National Register of Historic Places
1980s	Batteries Burchsted and Page lost to erosion
1988	Massive cleanup of island staged by U.S. military and conservation groups
1989	New automated light installed in lighthouse
1990s	Egmont Key Alliance volunteer group formed

1997 Egmont Key Alliance raises $140,000 for restoration of Fort Dade guardhouse

2000 Sand replenishment of shoreline is done by U.S. Army Corps of Engineers

2006 Additional sand replenishment done by U.S. Army Corps of Engineers

2009 Controlled burn of 65 acres on island held

2011 14th annual Discover the Island event held by Egmont Key Alliance

INTRODUCTION

E gmont Key has been a sentinel for ships entering Tampa Bay from the Gulf of Mexico for hundreds of years. Its history dates from before the arrival of the Spanish explorers and their contact with the native Tocobaga Indians in the early 1500s. The Spanish and other Europeans who followed recognized the island's strategic location. The history of the island reflects the major events in the history of the United States and Florida; it played a role in the Seminole Wars, the Civil War, the Spanish-American War and both world wars. Its lighthouse, now automated, is still a beacon for ships.

For many years people have enjoyed the beaches of Egmont Key, arriving by private boat or by ferry from Fort De Soto Park or Cortez. They walked the red brick "roads to nowhere" and perhaps might have wondered why they were there or what might have been there in the past. However, there generally seems to be little knowledge of the island's long and significant history. It is our goal that readers of this book will come away with an appreciation of the uniqueness and beauty of Egmont Key, as well as an understanding of its place in history.

We became curious about Egmont Key when we first started spending winters in the area over ten years ago, and we have made frequent trips across the Sunshine Skyway Bridge to visit our daughter in St. Petersburg. We saw the lighthouse in the distance and often wondered if it were possible to visit the island. We also saw a television program about it, which further intrigued us. Then, after a chance meeting with Sandie Mallett, then president of the volunteer group Egmont Key Alliance, we were invited to

join the organization. And that opportunity spurred a continuing interest in Egmont Key. Around the same time, Don met a longtime area resident and author, Libby Warner, who introduced him to Roberta Moore Cole, the daughter of Charlie Moore. Moore supervised the building of Fort Dade on Egmont Key, beginning in 1898. Roberta's grandfather, Charles Moore, was a lighthouse keeper on Egmont Key. Her fascinating stories of her early childhood on the island helped to inspire this book.

As a volunteer with the Egmont Key Alliance, Don developed an appreciation not only for the island's history but for its beauty, wildlife and plants. The Egmont Key Alliance strives to promote and maintain the island by acting as bird stewards during nesting season, clearing the beach of debris (especially before the sea turtles nest) and controlling invasive plant species such as Brazilian pepper. Today, Egmont Key is both a National Wildlife Refuge and a Florida State Park. It is our hope that future generations will continue to appreciate and enjoy Egmont Key, as well as protect it.

NATIVE AMERICANS AT EGMONT KEY

From the air, Egmont Key appears like a teardrop at the mouth of Tampa Bay, a low-lying, 1.7-mile-long sandy island. Its width has undergone much change over the centuries. Today, it is about half a mile wide at its widest point. For many years, it has served as a sentinel for the passage of ships to various Tampa Bay ports.

Until around 11,000 years ago, Egmont Key was part of the larger peninsula of Florida, the coastline of which extended about 100 miles farther into the Gulf of Mexico. During the end of the Pleistocene period, the ice fields of the Wisconsin Glacial period retained large quantities of water, making the sea level surrounding Florida about 200 feet lower than it is today. Due to a cooler, drier climate, grasslands, prairies and scrub oak woodlands flourished across the Tampa Bay region. At the end of this time period, Paleoindians, the earliest human inhabitants of North America, migrated into Florida as hunters and gatherers. They were skilled hunters with the atlatl, a type of throwing spear with a stone point, which they used to bring down mammoths, mastodons and large bison.

When the Ice Age ended, water from the melting glaciers flooded the coastline, the climate changed and huge animals like the mastodon disappeared from the area. The fossilized mastodon tusk pictured on page 17 was discovered in 2005 at the site of the former Palma Sola Golf Course in Bradenton, while the land was being excavated for a housing development. It is now preserved in plaster of Paris and can be seen at the South Florida

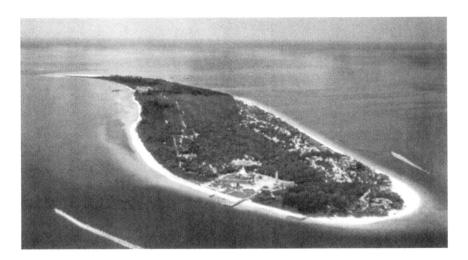

Aerial view of Egmont Key today. *Collection of Egmont Key Alliance.*

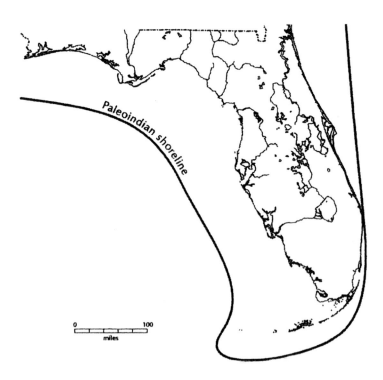

Map showing Florida during the Pleistocene period. *Sketch from Florida Indians and the Invasion from Europe, by JT Milanick, used with permission.*

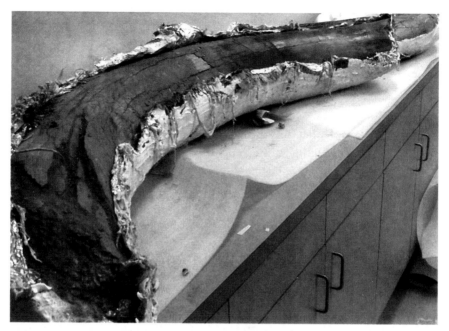

Mastodon tusk found near the Gulf Coast, south of Egmont Key, on display at the South Florida Museum. *Photo by author.*

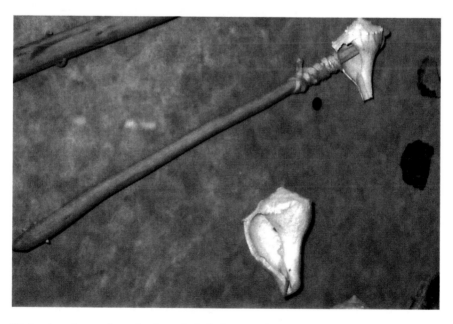

Native American tools made of conch shells from the Gulf of Mexico, on display at the South Florida Museum. *Photo by author.*

Museum in Bradenton. The display there also allows visitors to compare the relative sizes of the Paleoindians and their huge prey.

By the beginning of the Archaic stage (approximately 7500 BC), the sea level had reached near its present-day level. Archaic populations lived in small villages along the new coastline, taking advantage of the abundance of life in the Gulf of Mexico. Conch, clams, oysters, reptiles and a large variety of fish were plentiful. Early Native Americans made use of natural land resources as well, including acorns, berries and game animals. By the later Woodland period (500 BC–AD 900), an extensive trade network had developed, allowing native populations along the Gulf Coast to trade for chert, a hard stone used to make projectile points, found in the Tarpon Springs and Crystal River areas, as well as farther north. Chert points were used for hunting game such as deer and rabbits, and are also used as tools for scraping animal hides or as drills. Besides chert, coastal groups often used the teeth from extinct giant mako sharks as cutting tools. With these primitive but effective tools they could work wood from cypress, basswood, gumbo-limbo and sea grape trees.

The Tocobaga Indians (the Mississippi period, between AD 900–1500) made stone and shell tools to gouge out canoes from single yellow pine or cypress trees, using the chip and burn method. With the creation of canoes, they could make the dangerous voyage to Egmont Key to hunt or fish, usually for mullet and tarpon. Archaeologists have discovered over a hundred prehistoric canoes in Florida, frequently preserved in peat bogs.

As early as 1000–700 BC, the native people of Tampa Bay began to create mounds to bury their dead, covering them with sand and shells. The first mounds typically measured two to nine feet high and were about a hundred feet wide. Over time, as the mounds grew higher and higher, succeeding generations began to use them as a foundation for settlements. The mounds provided protection from tidal flooding and some relief from the hordes of mosquitoes and sand gnats in the low-lying areas. With the arrival of the cold north winds in winter, villages were abandoned for sites farther inland, and the people substituted their diet with what they could gather or hunt in the more wooded areas, such as berries and small game, for the fish and shellfish they ate while on the coast.

Archaeologists believe the first temple mounds were built in the Tampa Bay area around AD 700–1700. They served as ceremonial sites, and the chief, or *cacique*, built his home on the top. The temple mounds also provided a good vantage point for lookouts to spot approaching enemies. Before the arrival of the Spanish in the early 1500s, at least twenty temple

Indian shell mound that once stood next to the St. Petersburg Hospital. Postcard dated 1948. *Author's collection.*

mounds were built around the Tampa Bay area by the Tocobaga, Uzita and Calusa, who lived south of the Manatee River. Many of these mounds were destroyed during the early1900s and used for road construction. Only six have survived until today. Early Spanish records and these six mounds are all that remain to help understand the life of these early tribes. The De Soto expedition records contact with the Uzita on the Little Manatee River in 1539, but no later mention is made of them.

Spanish records tell us that most Tocabaga warriors were six to seven feet tall and were covered with elaborate body tattoos. According to I. Mac Perry, "Thorn punctures were made in specific designs over the arms, legs and bodies of both men and women. Juices from red and blue berries and gray charcoal dust were rubbed into the punctures. Often sickness followed as the wounds scabbed over." The Tocobaga were also described as "handsome men and women of great physique, bronze in color and dressed in skins of wild animals and Spanish moss, living in well-built palm-thatched homes atop large mounds of shells."

Unfortunately, European contact brought disaster to early Florida tribes such as the Tocobaga. Along with trinkets for trade, the European explorers brought communicable diseases such as smallpox and measles, to which the natives had no natural immunity. Many died, and others were sold

into slavery, some possibly shipped to Cuba as slaves. Between 1613 and 1617, the native population was reduced to half its size. By 1728, the few survivors were living in small dilapidated villages. Of those who survived, it is believed they eventually may have been assimilated into Seminole culture as the Seminoles migrated south around 1750 from present-day Georgia into Florida. Within a few hundred years after the arrival of Europeans, virtually none of Florida's original people were left.

In 1977, archaeologists made a reconnaissance-level survey to locate possible prehistoric sites in the southern part of Egmont Key, within the National Wildlife Refuge. Little evidence of permanent Native American settlement was discovered, possibly due to the lack of much fresh water and the strong currents of the Egmont Channel, which made voyage in primitive vessels hazardous. A few projectile points such as arrowheads and spear points were found on the island, and Spanish records indicate the presence of Native Americans on Egmont Key. Spanish explorer Francisco Celi, pilot of the Royal Spanish Fleet, noted finding an abandoned canoe along the shore of Egmont Key in 1757. Prehistoric Indians probably visited the island periodically to fish and hunt for nesting birds or turtle eggs. To this day, sea turtles come ashore on Egmont Key to lay their eggs each year, and the wildlife refuge shelters numerous species of nesting birds.

EUROPEANS ARRIVE ON FLORIDA'S GULF COAST

B eginning in the early 1500s, Egmont Key was discovered and rediscovered several times, first by the Spanish, then by England and France, as explorers from each country passed by this outermost island at the mouth of Tampa Bay. Spain's Ponce de Leon, famous in history for seeking the fabled Fountain of Youth, may have been the first European to reach Egmont Key after landing near St. Augustine on Easter Day, sometimes called "the Feast of the Flowers," in 1513. He named the land he found "La Florida." Historians are not certain if he actually did get to Egmont Key, however, because his logs and diary were later lost, and the Spanish often confused Tampa Bay with Charlotte Harbor farther south.

Eighty years later, Spanish historian Herrera used Ponce de Leon's logs to describe his stay on an island in the Gulf of Mexico, where he obtained firewood and fresh water and cleaned the barnacles off the boat's hull. In *The Mangrove Coast*, Karl Bickel states, "either off one of the keys of Charlotte Harbor or the low-lying shores of Egmont Key in Tampa Bay, the first white man was killed in a battle with local Indians." Bickel also mentions that Ponce de Leon was later fatally wounded in an engagement with native people.

During the first half of the sixteenth century, Spanish explorers made many voyages along the Gulf Coast: Diego Miruelo in 1516; Francisco Hernandez de Cordoba in 1517; Francisco de Garey in 1519; Panfilo de Narvaez in 1528; and Hernando de Soto in 1539. There were frequent clashes between the Spanish and Native Americans at the time, such as

when Frey Cancer's attempts to convert the Indians to Christianity in 1549 resulted in his murder.

During the Narvaez expedition of 1528, the soldiers sent ashore were soon captured by the Tocobaga Indians and killed in retaliation for the cruel treatment of their people by the Spanish. One soldier, Juan Ortiz, was saved by the intervention of the chief's daughter and became a slave in the Tocobaga settlement. He nearly lost his life again later when he fell asleep during his assigned guard duty but, once more, the chief's daughter successfully pleaded for him. With her assistance, he eventually escaped his captors and traveled to other Indian settlements, where he learned their languages. When Hernando de Soto set foot on shore in Tampa Bay in 1539, imagine his surprise when he was met by a man who spoke Spanish and claimed to be Juan Ortiz of Seville, Spain. Ortiz joined de Soto's forces, and his knowledge of Native American languages and customs quickly made him into a valuable asset. Unfortunately for Ortiz, de Soto did not prove to be an asset to him. Ortiz died while accompanying the de Soto expedition through Indian territory and never returned to his homeland, but tales of his adventures survive today.

In 1539, conquistador Hernando de Soto is said to have built a simple fort of palm tree logs placed upright in the ground as protection from Native American attacks. Some historians believe Egmont Key served as a base for de Soto's expeditions along the Gulf Coast. The rough currents surrounding the island afforded some protection from attack by water, and the Spanish fortified it with six ships' cannons and thirty soldiers. By 1565 the Spanish had built blockhouses on both Egmont Key and at present-day Safety Harbor, on Tampa Bay's north shore. The passage between Egmont Key and Mullet Key was known as Boca Grande ("Big Mouth"). It provided the deepest inlet to Tampa Bay both then and now.

For an extended period during the second half of the 1600s, the Spanish had little contact with the Florida Gulf Coast, largely due to their previous experiences with the Native Americans, which had often ended violently. According to some early accounts, around 1640, the French may have established a fort on Egmont Key to protect a colony they had started north of present-day Tarpon Springs. This colony turned out to be short-lived, and the French did not maintain any influence or presence on the Gulf Coast.

It was not until December 1756 that the Spanish first surveyed the Tampa Bay area. Juan Baptista Franco, a draftsman from Havana, Cuba, spent twenty-two days making a survey but, for some reason, he didn't include any charts of the bay. The following year, Francisco Maria Celi, pilot of the

Europeans Arrive on Florida's Gulf Coast

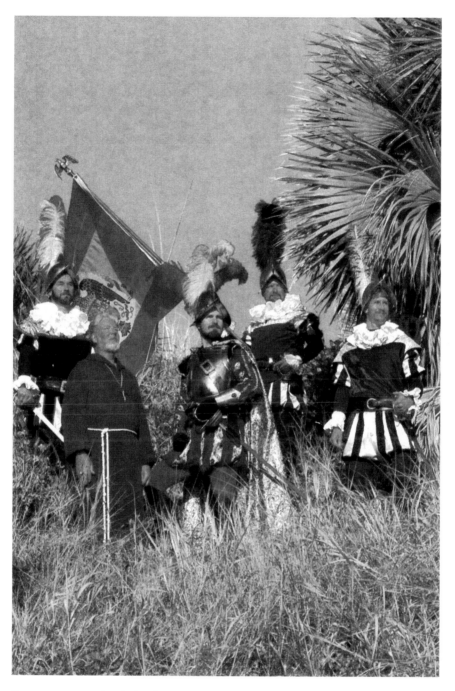

Reenactors portraying de Soto's landing in commemoration of the 450th anniversary at Hernando de Soto National Memorial in Bradenton, FL. *Author's collection.*

Royal Spanish Fleet, conducted another survey of Tampa Bay, including Egmont Key. He named the little island "Isla de San Blas y Barreda," in honor of his superior in Cuba. Celi's log records:

> *The xebec* [ship] *was anchored...we remained there until I examined and drew a sketch of the entrance and channels of this bay. At 8:00 a.m. Thursday, I went with the longboat to the Isla of San Blas y Barreda and in the name of God and the Most Holy Father, began to measure said island of San Blas. Starting from the southernmost part, I took measurements with a rope marker in Castillian yards* [thirty-three inches long].

After completing his survey, Celi explored Tampa Bay before returning to Isla de San Blas (Egmont Key). His log for Friday, May 6, records that members of the xebec crew returned to the island "to erect on the south point of this island the Most Holy Cross which was consecrated and set up in this position. The xebec saluted it with five salvos and dipped the flag at the stern." Later Spanish charts of Egmont Key and Tampa Bay designated the island as "Isla de Cruz," or "Cayo de Cruz," in reference to the cross, which could be spotted from a distance. Celi was so skilled at surveying that his measurements proved accurate more than two hundred years later in 1967, when modern surveyors compared them. It is important to note, however, that the destructive forces of wind and surf over the centuries continually change Egmont Key's dimensions. In 1875, the U.S. Coast and Geodetic Service survey concluded the island was "15–20% larger than shown by Celi, having grown significantly along the southwest shore as a result of sand deposition." About twenty years after the 1875 survey, two gun batteries were erected near the southwest shore, part of the fortification called Fort Dade, built to protect Tampa Bay. With constant erosion, these guns are now below the water.

In 1763, the Spanish regained Havana from the British in exchange for Florida. Two years later, a British naval pilot named George Gould arrived on the ship HMS *Alarm* to conduct a survey for Great Britain. A temporary fort was set up on Egmont Key. It consisted of two ships' guns set up behind a dirt breastwork to guard against surprise attack. Gould surveyed the island and gave it a new name: Egmont Key, in honor of the First Lord of the Admiralty, the Second Earl of Egmont, Sir John Perceval.

In his report during the 1760s, George Gould provided information about the features of Egmont Key. "It is about two miles long and better than one-quarter mile broad. The north end is highest, being about 6 or 7 feet above

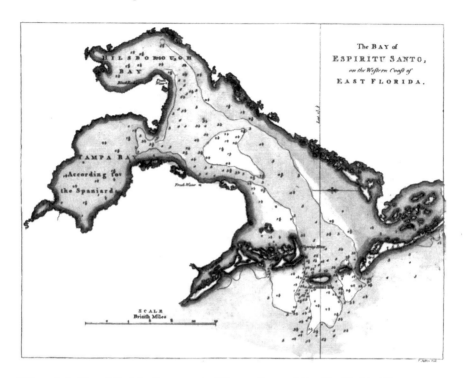

"Map of the Bay of Espiritu Santo on the Western Coast of East Florida," by Thomas Jefferys of London, 1777. *With permission from the Florida Center for Instructional Technology, University of South Florida.*

the high water mark...The soil is hardly anything but sand and shells. There are a few fresh water swamps, but the water is not good."

Gould also had been charged with determining whether British warships could use Tampa Bay. He concluded the best entrance channel into Tampa Bay was just north of Egmont Key, where "the water is 42 feet deep and extends within 60 yards of the north end of the key."

While Gould had named the island Egmont Key in 1763, it was known by other names as well. In 1769, Bernard Romans, a Dutch-born engineer, author and deputy surveyor for East Florida, produced a map of Tampa Bay for a book on east and west Florida. He labeled the island Castor Key, after a British pirate who supposedly used the island as a base. Interestingly, the engraver of Romans's map was none other than Paul Revere of Boston, soon to become a famous Revolutionary War patriot. The book was finally published in 1772, just a few years before the American Revolution.

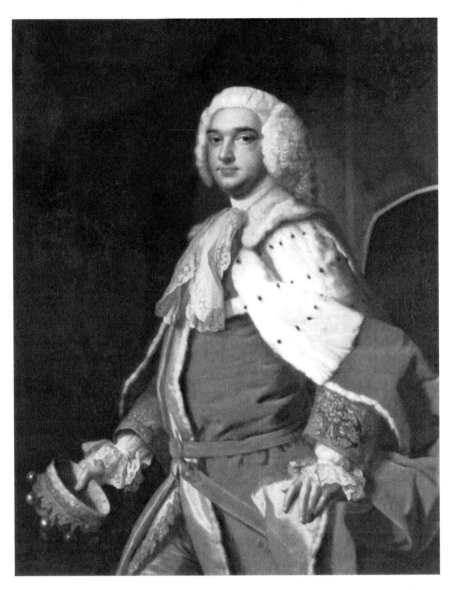

Portrait by Thomas Hudson of Sir John Perceval, the Second Earl of Egmont. *Wikipedia digital image from painting in National Portrait Gallery, London.*

Europeans Arrive on Florida's Gulf Coast

Pirates did apparently ply the waters near Egmont Key at various times. While making a survey of Tampa Bay, an English captain named Braddock of Virginia noted there was "growing pirate activity and the establishment of Cuban fishing ranchos along both coasts of Florida." One pirate tale, originating in the early 1800s, involves the infamous and ruthless pirate Pasqual Miguel and his crew. They happened upon a becalmed cargo ship named *Sunshine*, near the north end of Longboat Key. It was bound for Mobile with a cargo of $50,000 in silver and twenty-eight passengers, thirteen of whom were women and children. The pirates launched a longboat and offered to tow the ship to Egmont Key for twenty gold doubloons. The *Sunshine*'s captain thought the pirates were "honest Spanish fishermen," a fatal error in character judgment on his part, for the murderous Miguel and his crew boarded, brandishing cutlasses and pistols and herded everyone below deck. The unlucky *Sunshine* was looted, beached and set afire. There were no survivors. When word of this atrocity got out, the British warship *Albatross* soon arrived off Egmont Key, with orders to exterminate the pirates. Miguel had other ideas. He silently slipped his ship close to the British vessel and pounded it with cannonballs. The warship's guns were too close to be effective, so the British sustained many casualties before being able to get away. Pasqual Miguel was never caught, but it is said he met his end in 1813 at the hands of other pirates, who hung him on the north end of Anna Maria Island. Early settlers and local residents claimed traces of the sunken *Sunshine* could be seen up until the early twentieth century, off Anna Maria Island.

An official map of Florida was published in 1775, and the island was labeled Egmont Key. In spite of political upheavals, such as England trading Florida back to Spain after losing the Revolutionary War, the island's name has remained Egmont Key. Florida remained under Spanish rule for the next thirty-six years. Between 1817–18, during the First Seminole War, Andrew Jackson made an excursion into Florida in pursuit of the Seminoles and escaped slaves. Spain could not control Seminole raiding parties from crossing to Georgia and, by 1819, the ownership of Florida had become a burden. Spain also wanted to set a boundary between the U.S. and New Spain (Mexico), so a treaty was negotiated by John Quincy Adams, the secretary of state, and Luis de Onis, the Spanish foreign minister. Spain ceded Florida to the U.S. in return for settling a boundary dispute along the Sabine River in Texas. The United States also agreed to pay residents' claims against the Spanish government.

With Egmont Key now a recognized part of the United States, attempts to settle on the island were made. In 1821, two men tried to homestead

there but failed. In 1824, a soldier stationed at the newly built Fort Brooke on the Hillsborough River near Tampa visited the island and wrote about the "growth of live oak, red cedar and palmetto trees, with shafts of some about forty or fifty feet in height. These trees were sparsely scattered over the island, except near the center, where live oak and cedar form quite a hammock. We found sign of deer though none were seen, but the gray pelican, several species of gulls and great numbers of fish crows were observed." When the Armed Occupation Act of 1842 opened up southern Florida for homesteading, settlers began to go to Egmont Key. However, the secretary of war ruled that Egmont and other keys in the area were to be kept for military purposes, so homesteaders left the island.

The many different European individuals and groups who visited Egmont Key undoubtedly recognized the island's strategic location overlooking the entrance to Tampa Bay. Today, the island still guards the deepest and busiest shipping channel into Tampa.

CHAPTER THREE

LIGHTHOUSES AND HURRICANES

After the United States took control of the Florida peninsula in 1821, the federal government began the construction of lighthouses along the coastline. The first lighthouse was built on Anastasia Island near St. Augustine in 1824, but there was little commercial shipping activity in Tampa Bay at the time, so none was built at Egmont Key. However, by the 1830s, shipping had increased, along with the number of ship groundings on sandbars off Egmont Key.

During the Second Seminole War (1835–42), several ships bringing supplies to Fort Brooke missed the channel at night and became stranded on sandbars. A barrel painted black and white was placed on an eighty-foot spar at the north end of Egmont Key in 1836 to try to address the problem. Some records suggest a lighthouse may have existed there as early as 1823, but official government records show the first Egmont Key lighthouse was erected in 1848. Lieutenant Colonel Robert E. Lee, then a member of the Army Corps of Engineers, recommended the island be fortified as early as 1849, although the official government survey wasn't done until 1876, after the Civil War. Ironically, the island became a base for the Union blockade of Tampa Bay against Lee's Confederate forces.

With the passage of the Armed Occupation Homestead Act of 1842, Congress paved the way for settlement in Florida, initially giving settlers sixty acres of land. Statehood followed on March 3, 1845. Responding to requests from Tampa Bay residents, Florida's two new senators quickly pushed the federal government to build a lighthouse on Egmont Key. The

Florida General Assembly petitioned Congress in 1846 for the lighthouse funding and, the following year, Congress finally appropriated $10,000 for that purpose. The overseer of construction, Mr. Walker, surveyed the island in July and decided the best site for the new lighthouse was the northeast end, where it would be visible from all directions. The site was eight to twelve feet above the water line, and strong pilings supported the structure. The government contract specified a forty-foot-high brick tower with an eight-sided lantern room on the top to protect the lamps and reflectors. It also included provision for a thirty-four- by twenty-foot lightkeeper's dwelling, to be constructed one hundred feet from the tower in case it was demolished in a storm.

In August 1847, President James Polk ordered fifteen acres of land be reserved for the lighthouse; that November, Sherrod Edwards was appointed lightkeeper. Unfortunately, the construction met an unexpected snag: the builders ran out of bricks and mortar about halfway up. The supply ship delivering the bricks from New York City had run aground. Finally, on August 19, 1848, the lighthouse was finished and slightly under cost, at $7,050. It began operation the following May, projecting a fixed white light produced by thirteen lamps with twenty-one-inch reflectors.

Sherrod Edwards had been hired at an annual salary of $500 but, finding the need for an assistant, he agreed to take a pay cut of $200 in order to pay Marvel Edwards, likely his brother, to be assistant lightkeeper. However, Sherrod's tenure as lightkeeper was not long-lived. On September 25, 1848, a monster hurricane struck Tampa Bay. The storm surge covered Egmont Key with six feet of water. In *Tampa: A History of the City of Tampa and Tampa Bay Region of Florida*, Karl Grismer describes Edwards's response to the raging storm:

> [When he] *saw that waves were going to wash over the island, he placed his family in a boat and waded with it to the center of the island and tied it to a cabbage palm. During the night the boat was lashed by the raging wind and, on Monday, the high water had lifted it close to the top of the trees... They all survived the ordeal. When the water subsided the family returned home to find all its possessions had been washed away or ruined by the water.*

Local lore holds that Edwards and his family then rowed to Tampa, where he resigned as lightkeeper. However, other accounts claim he resigned halfway through the following year due to low pay. (The Egmont Key lightkeeper's salary was among the lowest on the Gulf

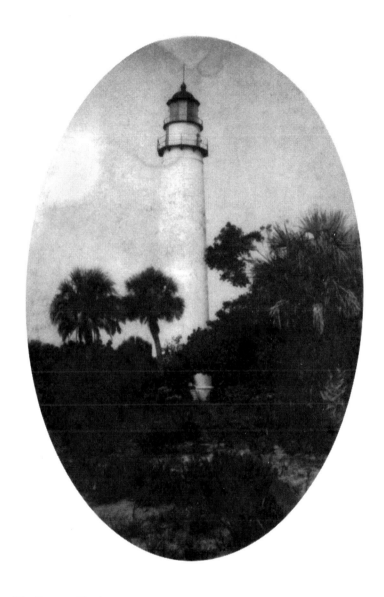

The Egmont Key Lighthouse, circa 1895. *Courtesy of Roberta Moore Cole.*

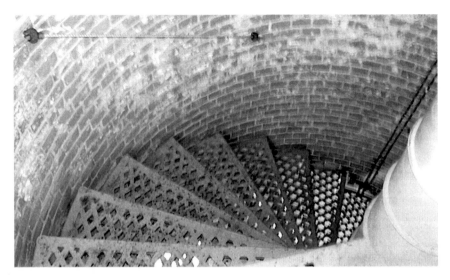

The lighthouse spiral stairway. *Photo by author.*

Coast.) Edwards was replaced by Michael Sheridan, who stayed only four months.

The lighthouse itself had sustained damage in the 1848 hurricane, so in 1849 the $2,200 remaining in the original congressional appropriation was spent in restoration. Concrete was poured around the tower to prevent undermining, and the leak in the dome was repaired. However, the structure was in poor condition, and after additional damage from later storms, it was decided to entirely rebuild the lighthouse and keeper's dwelling. On August 10, 1856, Congress approved $16,000 for the project.

Plans for the new lighthouse called for a three-foot-thick brick tower with an eighty-five-step cast iron spiral stairway. Metal alcoves at the base were probably used to store containers of fuel, such as whale oil or lard, burned to illuminate the Fresnel lenses. Whale oil was used early on, but by 1911, kerosene replaced the oil as the fuel of choice. When heated, kerosene would vaporize and produce a gas that burned brighter than whale oil in the mantle atop the lighthouse. Even after electricity came to the island around 1911, lightkeepers preferred kerosene for the quality of light it produced and continued to haul five-gallon containers up the eighty-five steps to the top.

During construction of the new lighthouse, the old lighthouse continued to operate, using the new fourth order Fresnel lens. The light beamed out forty-five feet above sea level and could project for fourteen miles in good weather. By 1858, the new lighthouse had been completed. It stood eighty-

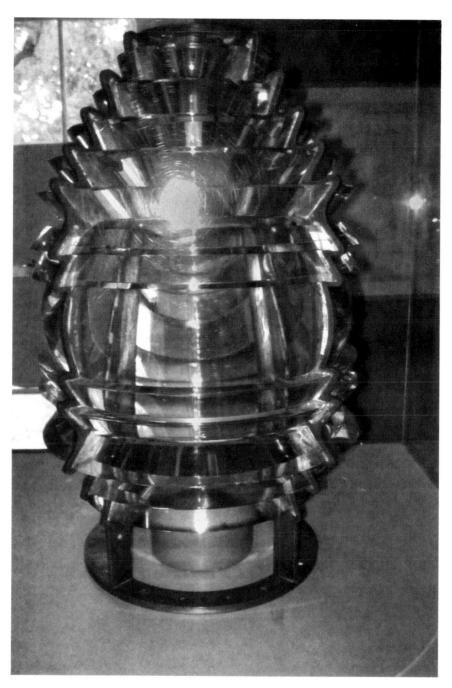

A third order Fresnel lens. *Photo by author.*

seven feet above water level and used a fifty-five-inch-tall third order Fresnel lens. The lens was made up of prisms, which bent and reflected the light to send out a narrow band that could be seen by passing ships. The lens was perfected by Augustin Fresnel of Paris, France, in 1822. There were seven sizes, ranging from first order (seven and a half feet) to sixth order (just sixteen inches tall). The Fresnel lens was not widely used in the United States until Congress mandated its use in all new lighthouses. The Fresnel lenses were superior to anything else of the time, and they are actually superior to today's lenses, but their weight, size and very high replacement cost made their continued use no longer feasible. Today, they can only be found in maritime museums.

As the lighthouse neared completion in 1858, the last Seminole prisoners held on Egmont Key were being sent west to reservations. The lighthouse has served as a beacon for ships entering Tampa Bay for over 150 years. The lighthouse, keepers' dwellings, outbuildings and trestle wharf were maintained first by the lightkeepers and later by the Coast Guard. In 1878, a severe gale swept away the wharf, and it was replaced in 1883 with one built of creosoted pilings. In 1899, a new assistant lightkeeper's house was built at a cost of $3,500 appropriated by Congress.

During the Civil War, the island was held briefly by the Confederates before being captured by Union forces in July 1861. Lighthouse keeper George Richards sympathized with the Confederacy, and he removed the lens from the lighthouse to hinder Union forces, taking it to Tampa for the duration of the war. Union soldiers used the lighthouse as a watchtower as they kept an eagle eye out for Confederate blockade runners. Egmont Key served as a staging ground for Union attacks on Tampa and Pinellas County.

In 1939, the United States Coast Guard assumed responsibility for operating the Egmont Key lighthouse. At that time, the lantern room was removed, and its remains can still be seen in a pile not far from the present-day picnic area. Workers affixed the light on a flat concrete slab at the top of the tower. In 1963, Florida's longest unspliced submerged power cable was laid across the shipping channel from Mullet Key to Egmont Key. The cable stretches 11,500 feet and is three inches in diameter. It lies sixty-five feet below the surface. With this improvement, Egmont Key was no longer dependent on a diesel-powered generator; it had progressed from using whale oil, kerosene and, during World War I, a 32-volt battery for its power source.

In 1989, a new light was installed on top of the lighthouse. The rotating light flashes every 15 seconds. A crew of four Coast Guardsmen was assigned to Egmont Key, and one of their duties was to turn the light on half an hour

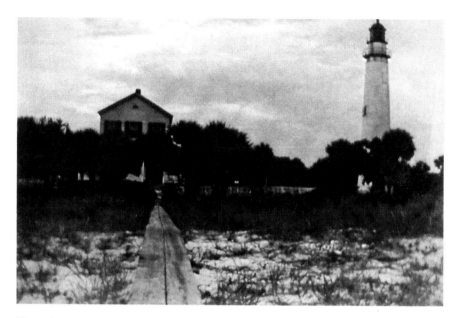

The assistant lightkeeper's house, circa 1895. The assistant's house was just south of the lighthouse. *Courtesy of Roberta Moore Cole.*

Remains of the lantern room, which was removed in 1947. *Photo by author.*

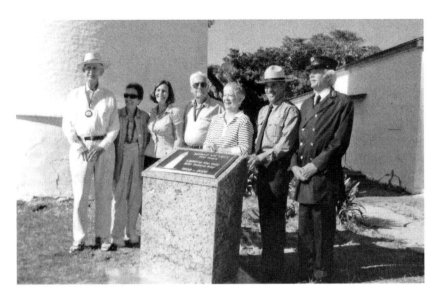

Celebration of the 150th anniversary of the Egmont Key Lighthouse. *Photo by author.*

before sunset and turn it off again half an hour after sunrise. Their other responsibilities included painting and other equipment maintenance, dock repairs and polishing the lantern. They worked in pairs for two-week shifts, with a week off on the mainland in between shifts, and they were transported back and forth by the pilot boat. Their quarters while on duty were inside the cement block building erected in the 1950s, just south of where the assistant lighthouse keeper's house once stood. For the crew's entertainment, they had a pool table, color television and a stereo. Besides maintaining the lighthouse, they also sent weather reports to the mainland every three hours and performed search and rescue operations when needed. When their duties allowed, they would show visitors the remains of Fort Dade's fortifications.

During Egmont Key's early lighthouse years, the lighthouse keepers sounded a foghorn to warn ships of heavy fog, but by 1930 a long wire radio antenna tower was erected to notify ships of adverse conditions. Its range was 175 miles at first and was later extended to 400 miles. This was in use until more modern technology, such as LORAN and GPS systems, came into use, making the radio tower obsolete. The Coast Guard removed the antenna and tower in 2005.

Today, visitors can read a plaque dedicated in November 2008, commemorating the Egmont Key lighthouse's 150 years of service, one of the oldest in existence in Florida. Since 2011 the Egmont Key Alliance,

a volunteer preservation organization, has added a line item to its annual budget for a lighthouse restoration and preservation fund. A current goal is to restore the lantern room to the lighthouse, returning it to its original 1858 appearance. They have contacted an architect with extensive lighthouse experience and a local metal fabricator about doing the work and are undertaking fundraising efforts for this project, as well as seeking support from U.S. and local governmental agencies.

THE SEMINOLE INDIAN WARS AND THE ROLE OF EGMONT KEY

Natives inhabited Florida for some 12,000 years before the arrival of Spanish, French and English explorers. By the early 1700s, Spanish missions located across northern Florida included about 26,000 Indians. But the arrival of British colonists from Georgia and their Creek allies in the early 1700s put an end to the Christian missions established by the Spanish. The British claimed they were seeking runaway black slaves and used this excuse to enslave the original inhabitants of Florida. The native population was further reduced drastically by European diseases, against which they had no immunity.

In what is now Georgia and Alabama, warfare between various Creek tribes pushed many Creeks off their ancestral lands and south into Florida, which was largely empty. The Creek Cowkeeper's Cuscowilla band, acting independently of other Creek tribes in Florida, eventually became known as the Seminoles. The Spanish named these immigrants to the area *cimaron*, meaning "wild one," or "those who broke away." The Creek, however, could not make the sound of "r" and transformed the name into Seminole. These Native Americans were mostly Hitchiti-speaking groups, which included the Oconee, Tamathli, Apalachicola and Chiaha.

By 1763, the Florida peninsula had come under the control of the British and remained under their control for twenty years before reverting to Spanish control in 1783, at the end of the American Revolutionary War. During both the American Revolution and the War of 1812, the Seminoles were allied with the British, which reinforced hatred toward the Americans.

In turn, the Americans resented the Seminoles for harboring runaway slaves from southern states, whose expanding plantation system required slave labor to be profitable.

The Seminoles began raising cattle on the land once occupied by earlier Native American tribes. As white settlers from the newly independent United States began moving south into this territory, clashes with the Seminoles were inevitable. The Americans occupied the land and raided Seminole settlements to recapture runaway slaves and steal cattle. The Seminoles retaliated with raids into Georgia and South Carolina, burning homesteads and killing their owners. War seemed unavoidable.

The First Seminole War was surprisingly brief. It began on November 21, 1817, when General Gates sent 250 soldiers from Fort Scott to arrest Chief Neamathla after his threats to kill any Americans found trespassing on Indian land. The Seminoles resisted and gunfire broke out. About a week later a boatload of soldiers bringing supplies to Fort Scott on the Apalachicola River were ambushed. General Andrew Jackson, the hero of the Battle of New Orleans, was dispatched to control the situation. On March 8, 1818, General Jackson, with a force of 3,500 men, 2,000 of whom were Creek Indian mercenaries, crossed the Florida border to attack the Spanish fort at St. Marks, which was held by Seminoles and black runaway slaves. However, the Seminoles had fled before the arrival of the troops. Jackson then marched his force east to the Suwanee River, where the Indians once again escaped into the swamps. As Jackson's troops pursued the Seminoles, they destroyed about twenty villages and seized the Indians' corn, hogs and cattle. General Jackson then turned his force west again to attack the Spanish fort at Pensacola, which was captured after a three-day battle, thus ending the First Seminole War in May 1818.

As a result, runaway slaves were returned to Georgia plantation owners and any captured Seminoles were sent to an inland reservation. However, the end of the war was not marked by a decisive defeat of the Seminoles, Miccosukees and their black allies, and they lived on to fight another day farther south. General Jackson did achieve the major goal of quieting border tensions between the Seminoles and white settlers, but the question of Seminole boundaries was not settled; the Seminoles still considered Florida to be their territory.

In 1819, secretary of state John Quincy Adams negotiated a treaty with Spanish minister Luis de Onis to cede Florida to the United States, ending thirty-six years of Spanish rule in Florida. In return, the United States gave up any claim to Texas and settled the claims of U.S. citizens against the

government of Spain. Many historians believe the young country of the United States never paid a penny for the valuable acquisition of Florida.

Two years later, in October 1821, Andrew Jackson resigned as governor of the territories of east and west Florida and returned to his home in Nashville, Tennessee. Seven years later he was elected President of the United States. In the time between the end of the first Seminole War and Jackson's election, things had only gotten worse for the Seminoles. A treaty signed in 1823 by Indian leaders gave up territory, and the Seminoles were forced to move to a reservation inland that had no Atlantic or Gulf frontage. They had to leave their cultivated fields and former hunting grounds and, desperate for food, they encroached on white settlers' land, stealing cattle and crops. As conflict increased between white settlers and the Seminoles, President Jackson persuaded Congress to pass the Indian Removal Act in 1830. It called for removal of the Seminoles to Oklahoma within three years. A Seminole delegation went to inspect the land they would be given and were persuaded by Indian agents to sign the agreement before discussion with the rest of their people. At the end of the three-year grace period, no Seminoles had yet moved west, so another treaty was signed in 1835, reaffirming the terms of the previous one.

Soon after the passage of the Indian Removal Act, the U.S. army built a stockade on Egmont Key to house the Seminoles before they were sent first to New Orleans and then on to the Oklahoma Territory. A garrison was stationed there to keep an eye on any Seminoles who might try to brave the swift current between Egmont Key and Mullet Key to escape. The 1835 treaty had been signed by a small group of elder chiefs after a severe drought hit Florida in the 1830s, but most of the younger chiefs did not favor removal to Oklahoma. This disagreement within their ranks eventually led to the election of one of the younger men, Osceola, as war chief to lead a resistance movement.

Osceola was a formidable leader, the son of a Creek mother and a Scottish trader by the name of William Powell. He organized the various groups who resisted removal and killed Chief Emathla, one of the proponents of moving west. Under Osceola's leadership, the frequency of raids increased, and this sent settlers flocking to area forts for protection. On December 28, 1835, Osceola killed U.S. Indian agent Wiley Thompson in a well-planned raid at Fort King. To give former General Thompson some credit, he had seemed to try to get to the bottom of the Seminoles' opinions, and he had lobbied Congress to pass a law prohibiting the sale of liquor to the Indians, which he felt only compounded the problems. However, as a southerner and slave owner,

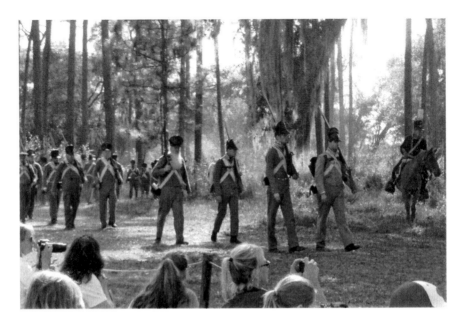

Dade Battle reenactment, January 7, 2012. *Photo by author.*

Thompson blamed the Seminoles for their influence on runaway slaves and apparently never recognized until too late the degree of resistance to relocation among the Seminole people. Indeed, the U.S. government consistently underestimated the resistance and fighting abilities of the Seminoles.

The same day as the attack on Fort King near Ocala, Seminole warriors attacked Major Francis L. Dade and 108 soldiers, reinforcements sent from Fort Brooke in Tampa to aid Fort King, which was about 100 miles and an eight-day march away. The Seminoles shadowed the American troops for five days until they reached the perfect ambush spot chosen by Chief Alligator, with a marshy pond on the east and heavily wooded on the other three sides. This spot is near present-day Bushnell. The band of 180 Seminoles opened fire, and Major Dade was killed in the first volley. The battle continued for eight hours until the U.S. soldiers ran out of ammunition. Only three Americans survived the battle, which became known as "The Dade Massacre." Two of the survivors were Louis Pacheco, a black man who spoke some Seminole and had acted as guide, and Private Ransom Clark, who survived in spite of receiving six gunshot wounds. He later wrote a book about his experiences and went on speaking tours. More than sixty years later, Major Dade's memory was honored in the naming of the military base built on Egmont Key, what we know today as Fort Dade.

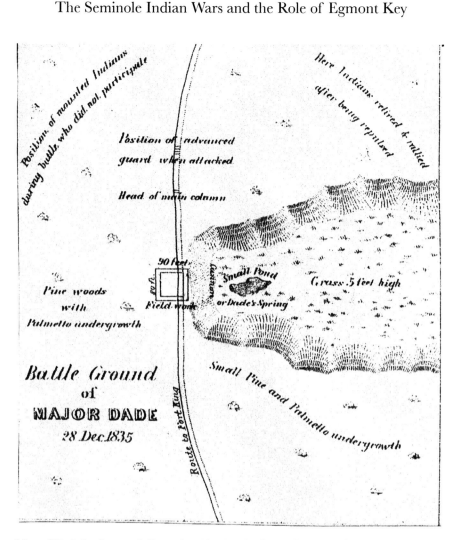

Map of Dade battleground, December 28, 1835, by Joseph Johnston. *Collection of the Seminole Wars Historic Foundation, National Archives.*

These two attacks on the same day started the Second Seminole War, one of the longest, costliest and bloodiest Indian wars in U.S. history. Ultimately, during the seven years of this war, 15,000 lives were lost, although among U.S. troops, more died as a result of diseases than were killed in combat. A long list of military leaders had command of the U.S. troops, but few could claim decisive victories as the Seminoles attacked swiftly and faded away into the swamps and underbrush. This was the U.S. army's first experience with fighting against guerilla-style warfare.

The Seminoles banded together under various brave leaders but never had a central war chief. The bravest and most renowned war leader, Osceola, was captured on October 27, 1837, and imprisoned, first at St. Augustine and then at Fort Moultrie, South Carolina, where he died in prison on January 31, 1838. He became something of a martyr for the Seminole cause and even for some in Congress who had opposed the war, considering it a fight to preserve slavery.

During the Second Seminole War, the Seminole population in Florida was reduced from 5,000 to several hundred, a result of casualties from the war and relocation to Indian territory in Arkansas and Oklahoma. It has been estimated that for every two Seminoles sent to Indian Territory, one American soldier died, either from battle or malaria or other illnesses. The last major battle was fought on Christmas Day in 1837, on the northeastern shore of Lake Okeechobee, a victory for future president General Zachary Taylor. By this time, Florida was considered the graveyard of military careers, and even Taylor's victory was doubtful as the Seminoles simply retreated into the swamps. By 1842, the federal government was heartily tired of pursuing the remaining Seminoles and the necessary allocation of manpower and funds. Congress passed the Armed Occupation Act of 1842, which gave 160 acres of land to homesteaders with the stipulations the landowners must build homes, be able to defend their own land and stay for five years. The Second Seminole War ended with the Seminoles never officially conquered. A peace treaty was never signed, leaving the Seminoles free to continue their claim to sovereignty and the door open to another war.

The three hundred or so Seminoles remaining in Florida were under the leadership of their acknowledged chief, Billy Bowlegs, the white man's name for Holatter Micco. In 1851, Luther Blake became the Indian agent whose task was to convince Bowlegs and his followers to honor the earlier agreements and relocate west to Indian Territory. To influence Bowlegs, Blake arranged a meeting for him and six other chiefs with President Millard Fillmore in Washington, D.C. President Fillmore gave Billy Bowlegs a silver Peace Medal, and Bowlegs and three of the chiefs signed an agreement to leave Florida. Before returning south, Bowlegs was given a tour of Baltimore, Philadelphia and New York City. When the mayor of New York asked him how healthy Florida was, Billy Bowlegs replied, "No, not healthy—there are too many whites in it." He was no doubt referring to the Armed Occupation Act of 1842, of which about 6,000 white settlers took advantage to claim their 160-acre plots of land. These settlers often let their cattle roam in the woods and were angry at any Seminoles who helped themselves to them.

The Seminole Indian Wars and the Role of Egmont Key

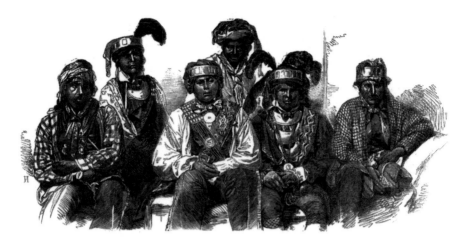

Sketch of six Seminole chiefs, including Billy Bowlegs, who met with President Fillmore. Illustrated London News, *1852 edition. Purchased from Createonline LTD.*

Once back in Florida, Billy Bowlegs and the other Seminoles ignored the agreement and resumed resistance to removal to Indian Territory. Thus began the Third Seminole War. Compared to the previous one, this war was much shorter and was less of a conflict, but it actually became the tipping point for the U.S. government's determination to remove every last Seminole from Florida. The government was simply tired of pursuing them. The Seminoles were vastly outnumbered, fourteen to one, and the best they could do was to launch small strikes here and there, ambushing groups of soldiers and attacking civilians upon occasion. In March 1856, the home of Dr. Joseph Braden (which still stands today in present-day Bradenton) was attacked and slaves taken captive.

In the end, the cessation of warfare came through negotiations in Washington. The Seminoles were granted their own lands in Oklahoma, separate from the Creek Indians. Billy Bowlegs and other leaders agreed to leave Florida in return for a payment of $7,500 to Bowlegs, as well as $1,000 each to four other leaders, $500 for each warrior and $400 for each woman and child, to be paid when they boarded the ship at Egmont Key. When Bowlegs and the others reached Egmont Key, they joined 46 prisoners already being held there. Among the first group of prisoners there was a Muskogee chief named Tommy. He and his family had been captured on the shores of Lake Okeechobee and were first held in Fort Myers. His wife and child escaped, but Tommy was ill and wound up at Egmont Key, where

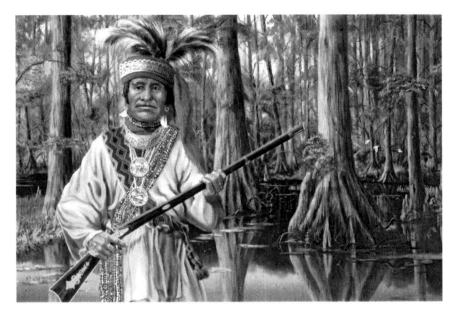

Billy Bowlegs, the Seminole leader at the end of the Third Seminole War, 1858. *Original drawing from* Florida's Lost Tribes *by Theodore Morris, used with the artist's permission.*

he subsequently died of dropsy in September 1857. At one point, there was an Indian cemetery on Egmont Key, located about halfway between the lighthouse and the island's south end. One estimate states that as many as 300 Seminoles were held on Egmont Key in 1858. An account by a mate on the government steamer *Texas Ranger* transporting Seminole prisoners to Egmont Key describes how the prisoners were quiet and orderly on the ship, until their arrival on the island, where many broke into weeping, dancing and shouting at the sight of their friends and relatives already there. Many were not overjoyed at being sent to Egmont Key, the first stop on the long trip to Oklahoma. A famous example is a Seminole leader named Tiger Tail, who rather than remain a prisoner, consumed ground glass and died. He may possibly be buried in Egmont Key's Indian cemetery.

Billy Bowlegs was only at Egmont Key for a few days before boarding the ship *Grey Cloud* on May 7, 1858, for Indian Territory. Interestingly, Billy Bowlegs survived to serve as a captain in the Union Army Indian Regiment, fighting pro-Confederate Indians. He died of smallpox during the winter of 1863–64. Some reports said that several Seminoles escaped from the *Grey Cloud* when it stopped at St. Marks and made their way back to southern Florida. Several small bands remained in the Everglades, never surrendering

to U.S. forces. Some of the surviving Seminoles who had eluded being sent west worked for Cuban fishermen and intermarried with them. There were complaints to Congress about these mixed families being rounded up by military authorities and sent to the western reservations after the Third Seminole War was over. Descendants of the Seminoles who remained in Florida still live on a reservation on the Tamiami Trail in southwest Florida. Only three years after the last prisoner was sent from Egmont Key to Oklahoma, the United States would face a much more devastating war that threatened the nation's continued existence: the Civil War. Egmont Key would play a significant role in this war as it had in the Seminole Wars.

EGMONT KEY
IN THE CIVIL WAR

E gmont Key had a significant role during the Civil War, as it became a focal point of the Union's efforts to limit or prevent trade between the Confederacy and foreign allies. Florida became the third state to secede from the Union on January 10, 1861, but it wasn't until April of that year that the war actually began with the attack on Fort Sumter in Charleston harbor. When President Abraham Lincoln first called for a naval blockade of the rebellious Southern states, it was nothing more than a "paper blockade," since there were only four ships ready for service. But by the end of first year of the war, 136 ships had been purchased and 52 more were built. The U.S. fleet, whose goal was foiling blockade runners, consisted of a variety of vessels, such as whalers, fishing schooners, ferry boats and excursion steamers, all armed for blockade duty. By 1862, the Gulf of Mexico had been divided into two Union blockade squadrons. The East Gulf Blockading Squadron covered the west coast of Florida, including Tampa Bay.

President Lincoln realized the Union Navy needed the Egmont Key lighthouse to guide the ships ordered to blockade the Southern ports. At the same time, the Confederacy knew if they could capture the lighthouse lens from Egmont, this would provide the cover of darkness, under which the blockade runners carrying needed supplies could slip past the blockade.

At the time of Florida's secession, the Egmont lighthouse keeper was thirty-two-year-old George Richards. He sympathized with the Confederate cause and waited for his opportunity to dismantle and remove the lighthouse lens and other equipment from Egmont Key. This was accomplished on

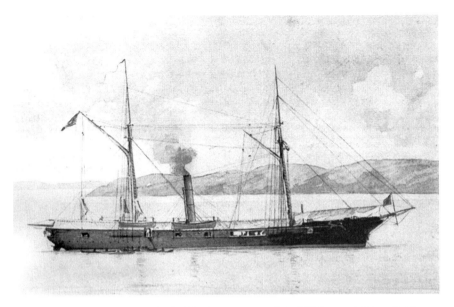

The USS *Tahoma*, a Union blockade ship that was part of the Hillsborough River Raid.
Sketch by R.G. Skerett, U.S. Naval Art Collection.

August 23, 1861, when the lens and ninety-six other pieces of equipment were spirited away to Tampa's Florida Railroad Depot. Interestingly, Lightkeeper Richards seems a man who had, if not divided loyalties, at least a willingness to serve two masters, as he was paid by both the Union and the Confederacy! The Confederacy eventually paid him thirty-two dollars for his efforts in rendering the lighthouse unusable. The third-order lens and other Egmont Key equipment remained in Tampa for the duration of the war. The Tampa Bay area became the base of operations for the Confederate blockade runners once the lighthouse was disabled. They took Southern products such as cotton, cattle and tobacco to the Caribbean in exchange for tea, coffee and desperately needed muskets for Confederate forces.

Union forces occupied Egmont Key in July 1861 and used the nonfunctional lighthouse as a watchtower to detect blockade runners attempting to sneak in or out of Tampa Bay. The Union made Egmont Key its base of operations for the East Gulf Blockading Squadron, and the Confederacy eventually moved its base south to Charlotte Harbor.

In February 1862, John A. Whitehurst, a Union sympathizer who had refused to join the Confederate army, was able to reach the Union ship

USS *Ethan Allen*. He reported he knew where the lighthouse equipment and 500 gallons of oil were stored. In return for this information, Whitehurst and his family were taken to Egmont Key to join the pro-Unionist refugee settlement there. He helped pilot Union ships for a time. That August, John Whitehurst, along with his brother, Scott, and another man named Arnold, went to the mainland to bring back food and livestock. They were attacked by Confederate guerillas. Scott and Arnold were killed, but John Whitehurst escaped, although badly wounded. He managed to get to his boat, where he lay for two days in the hot August sun before other Union sympathizers found him and took him back to Egmont Key. Before succumbing to his injuries, John told his story and expressed his desire that his three sons, ranging in age from seven to thirteen, be enlisted in the U.S. Navy. The older two boys actually did serve in the Navy. John Whitehead was buried in the small cemetery south of the lighthouse, where he remained until 1909, when all the Civil War burials were moved to the National Cemetery in St. Augustine, Florida.

Even before the war began—as early as 1859—boat captains such as Captain James McKay, with his single-crew steamer, the *Salvor*, were delivering herds of cattle to Cuba for cattle ranchers in the Tampa area. About 8,000 head of cattle were transported to Cuba each year and sold for fifteen dollars each in Spanish gold. It became an easy transition from cattle shipper to blockade runner. During much of the Civil War, Captain McKay was able to keep Fort Brooke and the citizens of Tampa supplied with goods brought past the Union blockade by his fleet of blockade runners. He is also given credit for creating the "Cowboy Cavalry" which drove the herds of cattle to the fighting Confederate army. He, along with businessman David Hope, operated the Jean Street Shipyard up the Hillsborough River, where the Confederate blockade runners were built and maintained. At the time, this location was considered safe from Union attack. Today, Captain McKay is considered the father of the maritime industry in Tampa. Captain McKay was bold, dedicated and determined. In October 1861, the *Salvor* was stopped by the USS *Keystone State*, and it was determined McKay was transporting a "cargo containing 600 pistols and 5000 percussion caps." McKay and his son were taken to Washington, D.C., as prisoners of war but were later pardoned by President Lincoln in return for swearing an oath of allegiance and promising to cease blockade running. Upon his return to Tampa, however, McKay quickly reneged on his oath and returned to his former occupation of blockade running, using the sailing sloop *Kate Dale* and side-wheeler steamship, *Scottish Chief*. In addition, he armed one of

his boats to capture Union vessels that were spying and illegally fishing in Florida waters. From 1862 to October 1863, he made six runs through the blockade. He carried cattle at first, but as the supply of beef became critical for the Confederate forces, he switched to cotton that was traded in Cuba for needed supplies.

With the resumption of McKay's activities, the Union navy made it almost a mission to put an end to his blockade-running career once and for all. In early October 1863, James Thompson of Tampa and Henry A. Crane, a printer for the *Tampa Herald* newspaper, led a hundred-man expedition known as the Hillsborough River Raid. Once Admiral Bailey learned the location of McKay's shipbuilding and blockade-running operation, he began to shell Tampa as a diversion. The paddle-wheel steamer *Adela* and the gunboat *Tahoma* both bombarded Fort Brooke in Tampa and then continued on to deliver Union forces to Ballast Point, where they marched along the Hillsborough River. Less than 160 families lived in Tampa at the time, and the attack devastated the community. Thompson and Crane's forces destroyed the blockade runner vessels at the Jean Street Shipyard. Captain McKay could only stand by helplessly and watch as the *Kate Dale* and the *Scottish Chief,* along with another ship, were destroyed. Five crewmen were captured, but several others escaped to Tampa and alerted the town of the attack. Once its primary mission was accomplished, the Union force marched fourteen miles back to Ballast Point, where Union ships awaited to return them to Egmont Key. However, before they could board, they were met by forty armed Confederates who happened to be in Tampa protecting the cattle drive to supply the army. The Battle of Ballast Point was a bloody one with heavy casualties on both sides. Both sides claimed victory, but the Union had successfully inflicted major damage on the blockade runners, especially James McKay, and destroyed a saltworks near what is now the Courtney Campbell Causeway. As the Civil War progressed, the East Gulf Squadron did a better job. As the sun set, the Union ships would lie in wait for blockade runners attempting to sneak through under the cover of darkness. By 1863, they had captured or destroyed 120 blockade runners.

The Union forces used a variety of vessels to patrol the river and coastline. It particularly made use of about twenty steam-powered ferryboats, which were converted into gunboats. The U.S. Navy favored these converted ferryboats because of their shallow draft, which made it possible to navigate rivers and streams in search or pursuit of blockade runners that were smuggling products (such as cotton and beef) to markets in the Caribbean. The USS *Fort Henry* is an example of one of these boats. It was a new boat

in 1862 when the Union took it over and armed it with two nine-inch smoothbore guns and four thirty-two-pound guns.

The *Fort Henry* was assigned to the East Gulf Blockading Squadron and served near Cedar Key. In 1863, it captured one sloop, and the following year, its tally was four schooners, four sloops and a small craft. In 1863, the *Fort Henry* went up the Crystal River in search of the blockade runner, *Frolic,* and during an attack upon a log breastwork onshore, two of its crew members were killed. Unfortunately, no picture of the USS *Fort Henry* survives, but it was similar to the USS *Commodore Perry*, pictured below. The *Commodore Perry* was part of the North Atlantic Squadron and was successful in various Union river expeditions. The USS *Fort Henry* made it back to New York after the Civil War but was lost in a fire in 1865. Several of the converted ferryboats returned to civilian service after the war and resumed their prewar names.

For years, there has been a mystery about the identity of the oak boat ribs from a nineteenth-century sloop, often visible at low tide in the Hillsborough

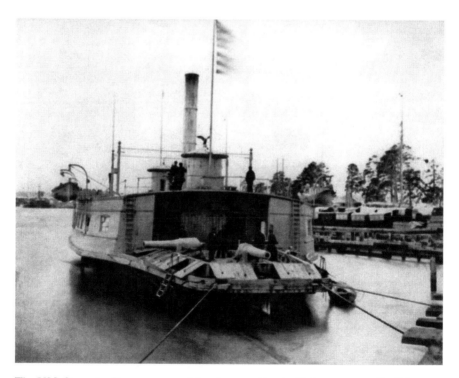

The USS *Commodore Perry*, a converted ferryboat used by the Union to pursue Confederate blockade runners. *Photo from the Photo Sharing Gallery.*

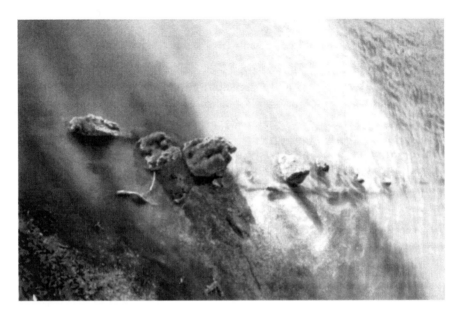

Oak ribs of wreck of the blockade runner *Kate Dale* in the Hillsborough River. *Photo courtesy of Jim Igler and the Florida Aquarium.*

River across from the Lowry Park Zoo. In 2008, through a state grant, the Florida Aquarium sent divers into the river for a closer look. It was determined the remains are of *Kate Dale*, the first Confederate blockade runner found in Florida. *Kate Dale* was a sleek, shallow draft sloop constructed of live oak and pine. On the night of October 16, 1883, it was anchored at the Jean Street Shipyard, its hold filled with cotton bound for Cuba once it evaded the Union blockade positioned north and south of Egmont Key. But on that fateful night, Union forces had discovered where *Kate Dale* and *Scottish Chief* were moored and marched overland to destroy the Confederate ships. *Kate Dale* lies where it was sunk 145 years ago.

Kate Dale was originally over eighty feet long, but the ruins are about thirty-eight feet in length. Once the sloop's location was identified, divers from the Florida Aquarium worked in the murky river to accurately measure and document the wreck, oblivious to the long hours, poor visibility and threat of alligators. Once historical and maritime records were checked, the site mapped and data recorded, the river mud was replaced around *Kate Dale*. No plans currently exist to bring it to the surface, as underwater archaeologists recognize that once underwater artifacts or wrecks are exposed to the air, they deteriorate rapidly.

Egmont Key in the Civil War

The 125-foot oak and pine *Scottish Chief* had been built in North Carolina in 1855 and was used to smuggle cotton and cattle hides through the blockade to Cuba. On its return trip, it brought guns, ammunition, Cuban cigars and fine wine, products the Union tried to restrict. *Scottish Chief* was not found near *Kate Dale* but was discovered downstream, near the Route 275 overpass across from Blake High School. It is believed that it was towed downriver by the Confederates, where they salvaged the engine workings and then sank the burned out hull. The Confederates also had destroyed the barge *Noyes*, to keep it out of Union hands. As a point of interest, the Jean Street Shipyard site still exists, downriver from where its one-time vessel, *Kate Dale*, rests.

At the start of the Civil War, 90 percent of Floridians supported the Confederacy, but as the war dragged on, more and more war-weary Floridians sought Union protection from Confederate forces that were seizing their livestock, food and crops. Many families in the area were left with very little on which to live. These desperate families often abandoned their homes and were taken by Union ships to a refugee community on Egmont Key, where they received rations from the Navy and tried to supplement their food supply by planting potatoes. During the early part of the war, Egmont Key also became home to escaped slaves, or "contrabands of war," as General Benjamin F. Butler called them in response to demands by a Confederate officer who came to claim runaway slaves. This designation prevented the slaves from being seized and returned without unduly upsetting slave owners in the border states aligned with the North. In August 1862, six whites and ten escaped slaves arrived on Egmont Key and helped the Union sailors there by washing clothes and catching fresh fish. By 1863, nearly 200 escaped slaves were living on Egmont Key, as well as a number of Confederate prisoners and Union sympathizers.

The Confederacy further damaged local support in several other ways. Until the spring of 1862, the Confederate army relied only on volunteers, but the Conscription Act that passed in April of that year froze one-year volunteer tours of duty for another two years. This led to an increased number of desertions among the ranks. By 1863, boys as young as fourteen and men over the age of fifty had been accepted as volunteers in the army. That year the Florida legislature passed the Impressment Act, which allowed Confederate agents to seize corn, beef and pork. The citizens were paid in Confederate dollars, which eventually became worthless as the Confederacy ran out of money.

During much of the Civil War, the Confederate government exempted from military service anyone who was a salt maker and who produced at least

twenty bushels of salt per day. Salt was very important for the preservation of meat and other food before refrigeration became available. It was a profitable business as well, with salt selling for a dollar to five dollars a pound. The Confederate coastline was dotted with wood-fired salt-making vats, in which saltwater was boiled down to extract the salt crystals. The Union army deliberately targeted these saltworks, destroying many by smashing the iron kettles with sledgehammers. In February 1864, the Confederate government removed salt makers from the exempted list, and this prompted many to join Union forces.

Union naval forces constructed several buildings near the lighthouse on Egmont Key and erected a gun battery on the bay side, facing Tampa. In May 1864, the Union navy sent ships from Egmont Key and succeeded in capturing Tampa. The invasion force was a joint army-navy effort consisting of 54 sailors and 230 men from the U.S. Second Florida Cavalry and the Second U.S. Colored Infantry. These last two units included a growing number of war-weary and disillusioned Floridians who joined the Union forces. They destroyed Fort Brooke and many other buildings in Tampa. Another important mission for the U.S. Second Florida Cavalry was to raid the two thousand head of cattle being moved north weekly to the Confederate armies in Tennessee and Georgia. At this point, Tampa was mostly abandoned and no longer had military significance. The combined Union troops took control of the nearly defenseless town, captured artillery pieces, killed or wounded some resisting Confederates and recovered much of the Egmont Key lighthouse equipment that had been removed previously. However, they were not able to discover the location of the lighthouse lens. Union troops did not permanently occupy Tampa until May 27, 1865, and it wasn't until then that the lighthouse equipment was returned to Egmont Key. It took three trips of the gunboat USS *Hendrick Hudson* to get it all moved back. Since the lighthouse was still not functional, the practice of sending two men to the top for lookout duty continued.

In February 1865, Michael J. Sullivan became the last Civil War sailor to be buried in the cemetery near the Egmont Key lighthouse. He had been on a mission to pursue three Confederate guerillas seen on Mullet Key, when his musket accidentally discharged, fatally wounding him. He was nineteen when he died.

Before the end of the Civil War, Egmont Key faced an enemy as deadly as any Confederate guerillas—a yellow fever epidemic. It began in Key West and spread to Tampa Bay when the admiral of the East Gulf Blockading Squadron sent most of his ships north. Commander

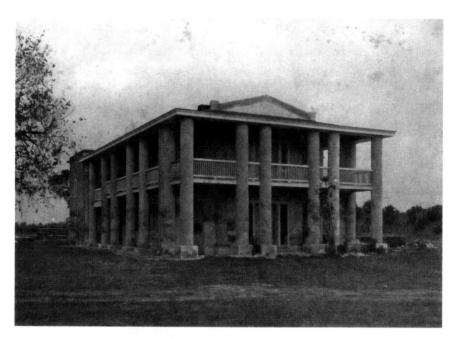

The Gamble Plantation Mansion in Ellenton, Florida. This place served as a refuge for Confederate Judah P. Benjamin during the aftermath of the Civil War. *Courtesy of the collection of the Gamble Plantation Mansion Historic Site.*

Chandler was sent to Egmont Key in July 1864 to build a coaling wharf and a thirty-bed hospital. The coaling wharf was completed in three weeks and could accommodate two vessels at a time. Once completed, the hospital was put to immediate use. The clipper ship *Roebuck* arrived with twenty-five of the crew sick with yellow fever, and at least twelve of them died. There were others ill as well, and fifteen yellow fever victims were buried in the cemetery south of the lighthouse during the months of July and August 1864.

The Gamble Mansion in present-day Ellenton is a state historic site and is open to the public. It was built in the mid-1840s by Major Robert Gamble, who established a sugar mill there. It was not a financially successful venture, so he sold it in 1858. In the spring of 1862, the Confederacy appointed blockade runner captain Archibald McNeill the caretaker of the plantation, and he lived there until 1878. In August 1864, a Union Navy raiding party burned the sugar mill but left the plantation house intact. When the Confederacy collapsed in 1865, Captain McNeill offered sanctuary to Judah P. Benjamin, the former Confederate secretary of state. Prominent former

Confederates, one of whom was Benjamin, attempted to flee any Northern retribution. He escaped Union troops by traveling south in a horse cart, disguised as a Frenchman and also as a farmer seeking land. He eventually arrived at Captain McNeill's home on the Manatee River. According to Lillie McDuffee in *The Lures of Manatee*, Benjamin was given "the best bedchamber, the large front room on the second story." He spent much time in front of the window with a spyglass, keeping watch for Union gunboats that might be searching for any escaping Confederates. The Union had offered a $50,000 reward for his capture, a good prize indeed for the time. Federal troops nearly caught up with him, but he fled again to the home of Captain Frederick Tresca, a French-born seaman and former Egmont Key lighthouse keeper. Tresca then agreed to transport Benjamin to the Bahamas for $1,500 in gold. Another man previously associated with Egmont Key, Hiram A. McLeod, joined them.

In June 1865, Benjamin and his supporters boarded a sailboat on Sarasota Bay and set a course south, using the sheltered bays along the coastline whenever possible to elude Federal gunboats. They once had to lower the mast to avoid detection while pursued. The Federal forces closed in another time and boarded the boat. Benjamin donned an apron and a skullcap and impersonated the cook, managing once again to elude his would-be captors. By early July, they had reached the Florida Keys and transferred to a larger sailboat to cross the open water to the Bahamas.

Upon reaching Bimini Island, Tresca received his $1,500 in gold, and Benjamin might have started thinking he was home free. But his adventures were far from over. He boarded a smaller sloop for the voyage to Nassau, and it sank thirty-five miles from land. Tresca and McLeod assisted Benjamin in getting another schooner, and he finally arrived safely in Nassau. From there, he traveled to Havana, Cuba, and then on to England, arriving on August 30, 1865. He lived in England for the next sixteen years working as a barrister (lawyer), in spite of some evidence linking him to the assassination of President Lincoln.

After the Civil War, the Egmont Key lighthouse was not back in operation until June 1866. A succession of lighthouse keepers were dismissed for various reasons, such as refusing the oath of allegiance to the U.S. government and neglect of duty in allowing the light to go out. During this post-war period, Caroline Coons became the only female assistant lighthouse keeper to serve at Egmont Key. During her term of service (1873–76), she was paid the standard wage of $400 a year. In the years following the war, more and more floating channel buoys delineating the Tampa shipping channels were put

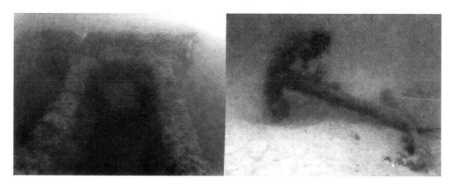

Underwater remains of the USS *Narcissus* off Egmont Key. *Courtesy of Genny Donaldson.*

into use. By the late 1880s, nearly all the buoys between St. Marks and Key West were serviced by the Egmont Key lighthouse keepers.

Today, there are few remnants of the Civil War on Egmont Key itself, but just off the northeast shoreline, in only 18–20 feet of water, lies the wreck of the USS *Narcissus*, a steamer that took part in the Union blockade of New Orleans. Its history is a remarkable one. The ship was launched out of East Albany, New York, in July 1863, as the *Mary Cook*. In February the following year, the Union navy purchased it and commissioned it as the USS *Narcissus*. It became part of the West Gulf Blockading Squadron at New Orleans. That summer, the *Narcissus* captured the sloop *Oregon* in Biloxi Bay. It was then ordered to support cleanup operations following a naval victory at Mobile Bay. During a heavy storm on December 7, 1864, the steamer struck a Confederate torpedo off Mobile and sank within fifteen minutes, luckily without loss of life. It was then raised and repaired at Pensacola early in 1865, and for the rest of the war, the *Narcissus* served as a dispatch boat. It left Pensacola on New Year's Day in 1866, and while near Egmont Key on January 4, a violent storm blew up. Strong waves crashed over the deck, and the boiler exploded, killing all twenty-nine persons on board. The State of Florida started surveying the wreck in the 1990s, but it wasn't until after the 2005 hurricane season that the wreck became more visible due to a shift in the sand. Since the fall of 2010, divers from the Florida Aquarium and a handful of archaeologists have been trying to make the shipwreck site Florida's twelfth Underwater Archaeological Preserve.

THREE GENERATIONS OF A LIGHTHOUSE FAMILY

A lighthouse has existed on Egmont Key since the Spanish built a wooden one on the north end of the island. As mentioned previously, a brick lighthouse was constructed in 1848, and after being damaged by a hurricane, it was replaced in 1858. Nineteen years later, in 1877, Captain Charles R. Moore became assistant lighthouse keeper. The following year, he was promoted to senior lighthouse keeper, a position he would hold for thirty-two years. Roberta Moore Cole, Charles R. Moore's granddaughter, recalled that her grandfather had found the remains of an old seventy-five-foot wooden lighthouse at the north end of the island in 1877, possibly dating from when the United States acquired Florida from Spain in 1821.

Captain Moore, born in 1838, was a Connecticut Yankee, and he had come to Tampa Bay after the Civil War. Before coming to Egmont Key, Charles Moore was a caretaker at Fort Brooke and ran a saltworks in the area. After a hurricane destroyed the saltworks, he transported mail from Cedar Key to Tampa. He once said, "I'm a 'damn Yankee,' but I like the town and I like the people, and I'm going to stay here—if they'll let me." A year after marrying Emily Rayfield Armour, he brought his wife and their eight-month-old son, Charlie, to Egmont Key. Evidently, "they" let him stay, as three generations of the Moore family lived on the island over the next forty-five years: Charles and Emily; their son, Charlie, and his wife, Roberta Lightfoot Moore (Berta); and Charlie and Berta's daughter, Roberta. Charlie Moore and family moved to Tampa when Fort Dade closed in 1922.

Between 1883–86, the government did not fund the position of assistant lighthouse keeper, so Captain Moore and his little family were the only residents on the island. These four years might have been quite lonely except for the steamer excursions that stopped at the island. The first mention of Henry B. Plant's steamer *Margaret* appeared in the lighthouse keeper's log on May 29, 1886. The family welcomed the passengers warmly and treated them as guests. Emily Moore collected shells and hand-painted scenes of the lighthouse on the reverse side, which at first she gave away to visitors as souvenirs. When the number of visitors became overwhelming, she began to charge for the shells and turned her parlor into a small gift shop.

The steamship *Margaret*, named after Henry B. Plant's second wife, made regular trips each Tuesday, Wednesday and Friday. It carried as many as 350 passengers, who paid two dollars each for the excursion. Emily Moore's gift shop became a popular attraction. Captain Moore was as popular as his gracious wife. One passenger recorded in her 1883 travel diary, "We found Captain Moore, the lightkeeper, an intelligent, kind-hearted and hospitable gentleman. He gave us interesting information concerning the island...He says there is a heron rookery on the island. He considers them his pets and will not allow them to be shot." In gratitude for the Moores' hospitality to his passengers, especially Mrs. Moore, Henry B. Plant wrote to her on April 26, 1895, inviting her to travel on his ship *Olivette* from Port Tampa to Boston. The Moore family appreciated his gesture, but Emily declined. She did take shorter trips, however. In 1889, the *Manatee River Journal* reported Mrs. Moore and a friend, Mrs. Perry, sailed from "Braidentown" (a variant spelling of Bradenton) to visit Tampa and Tarpon Springs for a few days. The steamers of the time stopped at Ellenton, Manatee, Braidentown, Palmetto and Palma Sola, in the days before the various modern bridges were built.

Other steamers stopped at Egmont Key, but the lighthouse keeper's log records details about the *Margaret* most frequently. Often, various organizations would plan excursions to the island, such as the Tampa Bay Cigar Makers and 300 members of the Christian and Temperance Society.

While most visitors to Egmont Key were warmly welcomed, there was one that was not: an epidemic of yellow fever. A quarantine station, part of the U.S. Marine Hospital Service, had been set up on Egmont Key. Yellow fever was a very serious threat in the 1800s. It got its name through the jaundice, or yellowing, of victims' skin the second or third day of the disease's onset. It still exists today, primarily in Africa and South America, but it is largely controlled through vaccination and mosquito control. It is an acute viral

Three Generations of a Lighthouse Family

Replica of Emily Moore's souvenir sunray shell, handpainted with the lighthouse on the inside. This replica was made by Egmont Key Alliance member Kathy Keleher. *Photo by author.*

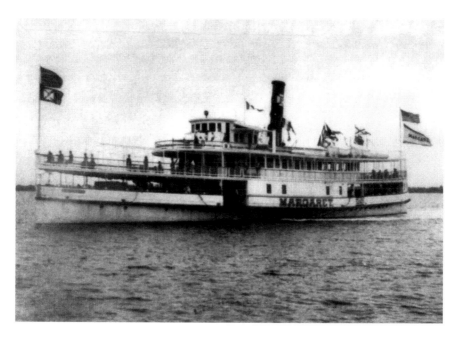

Henry B. Plant's steamer *Margaret* on excursion. *Courtesy of Roberta Moore Cole.*

disease that can be mild, with flu-like symptoms, or more severe, which can involve internal bleeding and death. People with the milder form are very sick but generally recover. Even with today's modern medicine, there is still no cure. Patients' symptoms are treated with rest, fluid replacement and, sometimes in severe cases, dialysis. Yellow fever is spread by infected *Aedes Aegypti* mosquitoes and not directly person to person, but this was not well understood in the nineteenth century, so victims were quarantined.

In 1887, during one such outbreak, steamer excursions were halted. Health authorities required that all passengers or crew who hadn't had yellow fever previously had to spend five to fifteen days in special detention hospitals, where they were fumigated. Tents for quarantined patients with yellow fever were set up on the island. An entry in the lighthouse keeper's log dated July 20, 1887, notes a Chinese man, Mr. Chow, had died of yellow fever. By August 1888, yellow fever reportedly had spread to Palmetto, and supplies and tents were moved to the southern end of the island. Two months later, Captain Moore's son and daughter-in-law, Charlie and Berta Moore, came down with yellow fever but survived. Dr. Pelot, a Manatee physician, called in Dr. John P. Wall from the Tampa Health Department at the start of this second yellow fever outbreak. He, in turn, sent for Dr. R.D. Murray, an expert on yellow fever from Key West. Dr. Murray imposed a quarantine. At first, Dr. Murray would not allow the steamer *Kissimmee* that provided service to Palmetto and Manatee to stop, but when the local inhabitants protested they needed to get supplies, he gave in. Guards, however, were posted to prevent other ships from coming and going without permission and inspection. Any home with yellow fever victims was required to fly a yellow flag. After the fever had passed, the house had to be whitewashed. Failure to do so resulted in a fine of five dollars. Bedding from fever victims had to be burned. All incoming and outgoing mail was fumigated, and no one could leave town without a permit. These restrictions were strictly enforced. Only one death from yellow fever was confirmed, although Dr. Murray was tending to as many as forty patients a day at the peak of the outbreak. Afterward, there was some question as to whether or not it really was yellow fever; the doctors couldn't agree. At any rate, many people became ill, and transportation, communication and life in general were badly disrupted for area residents during the epidemic.

By the following year, no more cases of yellow fever were reported, and groups began to come back to Egmont Key. The largest recorded excursion party was a group of 500 Florida teachers in 1891. Many of them made the

climb up to the top of the lighthouse to have their pictures taken, but visitors are no longer allowed that opportunity.

A lighthouse keeper's life was not an easy one. When Charles Moore became lighthouse keeper, oil for the light was delivered once a year. Each morning Captain Moore had to climb the eighty-five steps up the narrow cast iron spiral staircase to the lantern room. There he began the daily chores of adjusting the wicks, cleaning the chimneys and lenses, filling the lamps and washing the windows in the lantern room to prepare for the night. This work began at dawn and was finished around 10:00 a.m. To prevent sunlight from discoloring the glass lenses, a curtain was hung at dawn to block the sun's rays.

After the current lighthouse was constructed in 1858 (at a cost of $16,000), a small brick building was built nearby for oil storage. Another larger brick building was added in the 1920s to house the radio transmitter. The lighthouse dock was just south of the lighthouse keeper's house, and a shed on the land end provided buoy storage. For many years, all buoys used between St. Marks and Key West were maintained and stored by Egmont Key lighthouse keepers. This dock was destroyed or badly damaged by hurricanes numerous times during Captain Moore's tenure as lighthouse keeper. The keeper was expected to whitewash the lighthouse and other buildings and generally keep the property in good repair. By the 1890s, a fog bell costing $2,000 was installed to warn ships coming to and from Port Tampa.

In 1886, a new detached kitchen with a covered walkway to the house was built. One advantage to this detached kitchen is that, in the event of a kitchen fire, the house might be spared. Having the cookstove in a separate building also helped to keep the house from heating up during the summer. This kitchen building remained a feature of the lighthouse keeper's house until it was taken down in the early 1940s. By then it was in a poor state of repair. In 1898, the assistant lighthouse keeper's house was built at a cost of $3,500, and improvements were made to the Moore family's dwelling as well.

The lighthouse keeper's family produced much of their own food, especially in the early years. There was a freshwater pond near the island's interior, not far from the lighthouse, that provided water for a garden and animals. They also made use of a cistern to collect rainwater. Charles Moore had a successful vegetable garden that provided watermelon, tomatoes, onions and cabbage. He kept the garden fenced to keep out any hungry gopher tortoises. Captain Moore also grew enough oranges to send the surplus to be sold on the mainland via the weekly mail boat. The Moore family made use of native plants as well, particularly guavas, sea grapes and wild figs, which

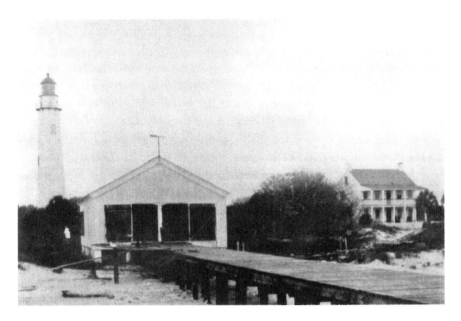

The lighthouse dock and shed where buoys were stored. *Courtesy of Roberta Moore Cole.*

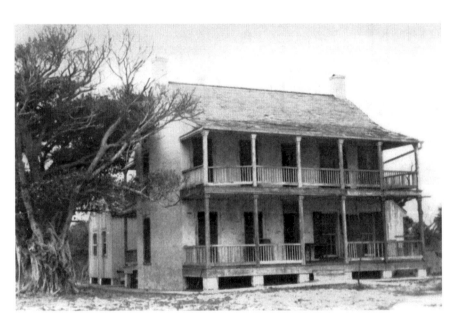

The lighthouse keeper's house, which sat just north of the dock. *Courtesy of Roberta Moore Cole.*

were made into jelly. Unfortunately, weeds also thrived around the property and had to be kept in check for fear of fire and to eliminate mosquitos.

Much of Captain Moore's time was taken up with his daily lighthouse duties, but he took time to enjoy fishing and hunting on Sundays. In 1889, there is a record of a "wild boar" being shot on Egmont Key, but it likely was a domestic pig that had gone feral. One day Captain Moore shot six quail, two hawks and a rattlesnake, but he would not hunt, nor allow anyone else to hunt, the herons he looked upon as pets. He built a chicken house and run so the family had a ready supply of eggs and chicken to eat. He often went fishing off the north end of the island where the water was deepest and brought home sea bass, grouper, bluefish, kingfish and mackerel for the family table. Fish and grits were a family favorite for breakfast.

Charles Mortimer Moore was Captain and Emily Moore's only child. He helped his father with the various tasks of operating the lighthouse, such as carrying oil to the lantern room to replenish the lamps, keeping up the property, scraping and painting the buoys and so forth. At age fifteen, he painted the interior tube of a whistling buoy. It was probably too narrow for his father to climb down inside. Charlie was educated at home by his mother until he was about fourteen, when he was sent to Fogartyville on the Manatee River to live with the Bartholomew (Bat) Fogarty family. There he continued his education and was apprenticed to learn the craft of boatbuilding. Later he attended Rollins College, where he studied engineering but never received a degree. He planned to work at building boats at Bat Fogarty's boatworks but left to take a job as a boatman for the Marine Hospital Service on Egmont Key. He became dissatisfied with the way the yellow fever quarantine camp was being run, so he got a job as a carpenter working to build Fort Dade on Egmont Key during the Spanish American War. He soon worked his way up to foreman and eventually became civilian construction chief for the U.S. Army Engineers, a job he would keep for twenty-four years.

Congress appropriated over $1 million to fortify Egmont Key and Mullet Key to protect against a Spanish invasion from Cuba. Charlie Moore designed and oversaw construction of seawalls, docks, storerooms, barracks and the fortified cement underground command center, where mines in the shipping channel could be set off electronically. Another underground casement was built to house a telephone switchboard. This was located just south of the old quartermaster's dock. By 1900, Egmont Key had its own post office, an improvement, as the Moore family and other island residents could now order items from Sears and Roebuck and have them delivered to the island by boat.

Captain Charles Moore showing off his catch of grouper. *Courtesy of Roberta Moore Cole.*

Three Generations of a Lighthouse Family

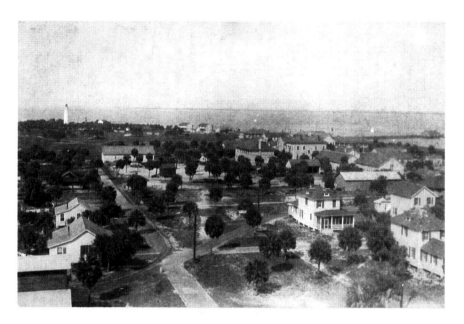

Fort Dade looking northeast, with the lighthouse in the background. *Courtesy of Dana Sanborn.*

A more recent story about the former nerve center comes from Brenda Humphries, a member of the Egmont Key Alliance. She recalls when she was about ten years old, along with her friends Carol and Billy, also age ten, and their parents, coming to Egmont Key from Bradenton in a wooden boat. As the children explored, they came upon the nerve center, which they christened "the hell casement" after looking in and noticing glowing remains of small fires here and there, improvised torches left behind by previous "explorers." They proceeded to light their own palm frond torches and entered, but after a few minutes inside the spooky interior, they abandoned their torches on the floor and went back outside to wander further on to the gun batteries on the southern end and to dive into the water from the top. Several generations of children have enjoyed exploring the abandoned remains of Fort Dade, but children today can't dive from Batteries Burchsted and Page as Brenda did, since those have slipped into the Gulf of Mexico due to erosion.

In May 1904, Charlie Moore married Roberta Lightfoot of Bradenton, the oldest of the Lightfoot girls who frequently visited the island. Charlie and Roberta's only child, also called Roberta, was born on August 26, 1910. She actually was not born on the island, however; her mother didn't trust

The nerve center from which mines were set off. *Courtesy of Roberta Moore Cole.*

Inside the nerve center today. *Photo by author.*

Three Generations of a Lighthouse Family

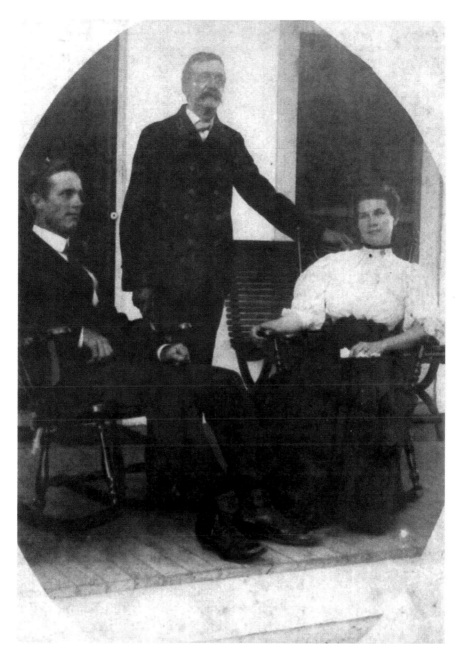

Captain Charles Moore (center) with son, Charlie, and his wife, Roberta Lightfoot Moore. *Courtesy of Roberta Moore Cole.*

The Junior Red Cross at Fort Dade. This photo was taken in the early twentieth century. Roberta Moore Cole is in the second row, on the far right end, with her hand on her face. *Courtesy of Roberta Moore Cole.*

the small military hospital on Egmont Key. So when her mother went into labor, Charlie took her to Bradenton, where Roberta was born. Roberta Moore Cole recalled her father had built the boat in which he took her expectant mother to the mainland, and he brought mother and baby back to the island in it.

Young Roberta spent the first ten years of her life on Egmont Key. She had what she considered the most perfect childhood there, although it might have been viewed as unconventional or unusual by town dwellers. Roberta was a precocious, curious child who had the run of the island, and in later years, she liked to tell others, "Egmont was my teacher. She taught me so much—not to fear, only respect for nature." Roberta's education began at age five, in Fort Dade's one-room school, but that only lasted a week. Roberta's mother felt the teacher had too many children to deal with and decided to educate her at home. She engaged the services of an officer's wife, a former teacher, to tutor Roberta and her little friend, Robert Stanton.

Roberta's parents tried to ensure their daughter had a well-rounded education. She accompanied her father as he oversaw construction of Fort Dade. She loved to use his spyglass to identify the various ships going to and from Port Tampa by their flags. Her father would tell her about the

countries from which they came, and they would speculate about the cargo they carried. She enjoyed watching the men load the little narrow gauge train that brought coal from the pier. It also was used to transport other things, and sometimes the load was too heavy, so the men would have to get it started with a push.

Roberta visited the other ladies with her mother and learned the social niceties of the day. She also endeavored to crochet and embroider, although she preferred to be outside and once commented it took her twenty-five years to finish an afghan. She learned to read at an early age and had an insatiable appetite for books, so much so that her parents would ration them out. Mrs. Moore hired a strict German woman to give her daughter piano lessons, and Roberta recalled wryly that her piano teacher would rap her knuckles at wrong notes. Mrs. Moore also decided that her daughter should have elocution lessons (public speaking), although Roberta wasn't too enthused about taking them. Roberta's young aunts came to visit often. They were extremely popular, each with a steady stream of hopeful young men from the military base. Mrs. Moore insisted Roberta always wear her Panama hat to shade her face from the strong sun and also made her wear shoes, although many other island children ran around barefoot.

Roberta recalled learning to ride a bicycle on the wooden sidewalk and then on cement sidewalks. She learned to swim on the bay side of the island but was once swept away from shore by a current and had to be rescued. During these early years, before the 1920s, bathing costumes covered their wearers so completely that sunburn wasn't a problem like it is today.

Roberta told a story about playing outdoors in the yard one time when she was quite small. She was busy making mud pies, but she kept hearing a strange buzzing or rattling sound. Fortunately, the little girl went and told her father about the strange noise. Upon investigation, he discovered a large rattlesnake nearby, which he shot and killed. Today it is believed there are no longer any rattlers left on Egmont Key, but during the Moores' residency, there certainly were. The lighthouse keepers' logs mention killing snakes a number of times.

Living at Fort Dade provided advantages for the family that people on the mainland did not have. There was a gymnasium and a movie theater. These were silent movies, accompanied by one of the enlisted men playing the piano on Saturday nights. On Sunday mornings, the piano was used for Sunday School hymns. There were no cars on Egmont Key, so people mostly got around by "ankle express," as Roberta put it, or by bicycle or horseback.

The Moore family traveled by boat to Bradenton every week to get supplies and to visit family and friends. Like many other island families, they raised some of their own food, but what they couldn't produce, such as meat or flour, they bought at the Fort Dade commissary or from the mainland. Charlie Moore kept chickens as his father had, and each year he entered his prize-winning poultry at the fair in Tampa. He also raised rabbits and had two cows that provided milk for the Moores and other families with children. The Moores typically had their main meal at noon, so that the iron cookstove could be fired up early in the day before it got too hot. The detached kitchen kept the main house cooler as well. Mrs. Moore enjoyed fish for breakfast, so Charlie would go out early with his fishing line and soon return with freshly caught mackerel. Roberta recalled that pot roast was a family noontime dinner favorite. In the evening, they usually had a cold meal, such as leftover cold chicken and cold mashed potatoes sprinkled with grated raw onion and vinegar as a potato salad. Food was kept cold in an old-fashioned icebox, with ice brought by soldiers from the fort.

When the armistice was signed on November 11, 1918, ending World War I, the Moore family realized their time of living on Egmont Key would be coming to an end. Charlie would need to find another job. They eventually moved to Tampa, where Roberta was enrolled in public school for the first time since beginning her education. At first, she was enrolled in first grade because school authorities questioned her lack of formal education, but thanks to her mother's hard work and her own quick mind, her education was not found to be lacking. She was soon promoted four grades. Her father began working for the Tampa Bay Pilots Association, where he was office manager and dispatcher for another twenty-five years, until he retired at age seventy-five.

Roberta went on to Florida State College for Women, where she trained as an elementary teacher. Later she started the speech therapy program for Miami Beach schools and supervised home-teaching services for the Florida Council for the Blind. Roberta married E. Ward ("Bud") Cole after meeting him at the Community Chest Agency, a volunteer organization in Tampa. She continued her speech therapy work in Hillsborough County after her marriage. Upon retirement, Roberta and Bud moved to Holmes Beach on Anna Maria Island, where they lived for sixteen years. They were active boaters and made many trips to Egmont Key. In her later years, Roberta Moore Cole became one of the area's prime sources of information about life on Egmont Key and gave many talks and interviews, including to the authors. She loved to reminisce about her days on the

island and clearly believed her experience there was a defining influence on her life and personality. Roberta Moore Cole lived to be just shy of one hundred years old. Few, if any, people remain today who remember firsthand what Egmont Key and Fort Dade were like in the first part of the twentieth century.

FORT DADE, 1898–PRESENT

THE SPANISH-AMERICAN WAR AND CONSTRUCTION OF FORT DADE

Starting with the second Seminole Indian War in 1840, Egmont Key became important for military purposes, due to its strategic position at the mouth of Tampa Bay. This kept out homesteaders and private developers who might have built on the island. In 1849, a group of U.S. army engineers that included Robert E. Lee suggested that Egmont Key be fortified. During the Civil War, a Tampa newspaper reported three Union cannons were on the north end of the island. However, in 1885, when the secretary of war recommended coastal fortifications be built, Tampa Bay was not one of the twenty-six suggested sites. At that time, Tampa's population was less than 1,000.

The call for Egmont Key's fortification began in 1884, when Henry B. Plant constructed first a narrow-gauge, followed by a standard-gauge, railroad line across Florida to Tampa. With improved transportation, industries flocked to the area, causing the population to swell almost overnight to 5,500 by 1890. In light of his considerable financial investments in building the railroad, a large pier for his shipping company and the luxury Tampa Bay Hotel, Plant successfully lobbied members of Congress to build a fort on Egmont Key to protect Tampa Bay from possible Spanish invasion. At the time, Spain had only four modern cruisers in Cuba.

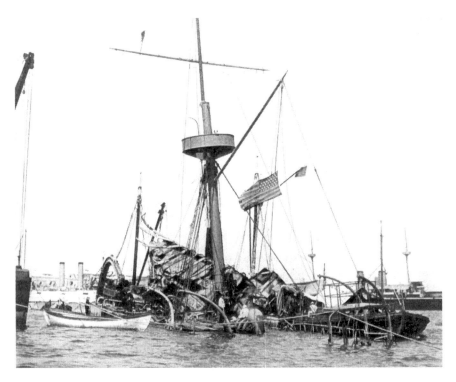

The USS *Maine* after exploding in Havana harbor. *Author's collection.*

When the USS *Maine* was sunk in the harbor at Havana, Cuba, on February 15, 1898, the United States declared war on Spain about two months later, on April 21, 1898. The federal government chose Tampa as the embarkation point for thousands of American forces preparing to invade Cuba. Tampa Bay had five army camps set up in the area. Plant's elegant Tampa Bay Hotel became the officers' quarters. The men spent eight weeks training and sweltering in their woolen uniforms in 90-degree heat and had poor-quality food that quickly spoiled. By June 7, 16,000 men prepared to board ships for Cuba. The pier was so congested with troops, supplies and equipment that boarding was very slow, and some men succumbed to sunstroke.

Teddy Roosevelt, whose Rough Riders were among the troops, was furious with the situation. He wrote to a friend in Boston, "It took us twelve hours to make the nine miles of railroad [to the wharf]. The only way we could locate a train was by seizing a passing coal train headed for the port." Only two ships could be loaded at a time, with a total of thirty-six heading

for Cuba, plus an escort of fourteen warships. At one point, it was rumored that a Spanish gunboat had been seen off Egmont Key, so the embarkation was halted for several hours. It turned out the boat in question was a U.S. ship on patrol. Once all the troop ships were finally loaded, they remained bobbing in the bay for another week, until it was determined there were no Spanish cruisers lurking nearby.

Finally, the invasion was underway, but the war was short-lived. After six uneventful days, the transports were off Santiago. The American forces were surprised to see their landing go unchallenged by the Spanish. It was all over by August 1898. The modest fleet of Spanish ships was no match for the United States Navy, and the Spanish ships were destroyed when trying to leave Santiago, Cuba, on July 3, 1898. It would later be proven that the *Maine* had exploded not from Cuban sabotage but from internal combustion of coal in the ship's hull.

The returning troops had to spend ten days at a yellow fever quarantine station consisting of 1,000 tents on Egmont Key, located just south of the lighthouse. Even Clara Barton, the seventy-seven-year-old founder of the Red Cross, was quarantined there for five days. John O'Neil, a Rough Rider from the First U.S. Cavalry, was on the first ship that carried some of the sickest troops leaving Cuba, bound for the nearest available Marine Hospital, which was on Egmont Key. Unfortunately, upon their arrival, nothing was in readiness; the tents were not set up, and there was not enough food and water for the dehydrated men. The sick men were returned to the ship, where some died, including John O'Neil. His death was caused by a combination of various factors, including dysentery, improper food, lack of medicine and a debilitating disease—likely malaria, yellow fever or typhoid. He was buried in the cemetery on Egmont Key. At the turn of the twentieth century, lighthouse keeper Charles Moore made a formal complaint about the cemetery's poor condition. The government decided against making improvements and closed it. In 1909, the remains of soldiers buried there were disinterred and removed to the National Cemetery in St. Augustine, Florida.

Even though the war was quickly over, the plans to build a military base on Egmont Key went forward. By the spring of 1898, construction of the fortifications had begun, with Fort Dade on Egmont and Fort De Soto on Mullet Key. At first, two temporary sand batteries were built on the north and south ends of Egmont Key to guard the shipping channels. These were completed by June 30, 1898, but they were not manned until January of the following year, well after the Spanish-American War was

over. Eventually five permanent batteries, made of cement or tabby (a mixture of lime, sand or gravel and shells) were built. In November 1898, the *Manatee Journal* reported:

> *The government has contracted for 42,000 barrels of cement to be used in erecting the forts at Egmont and Mullet Keys. The plans of these fortifications show that they will be the strongest on the American continent when completed. Several years will be required to finish them up, during which time there will be a good demand for labor and considerable quantities of fruits, vegetables and fresh meats, all of which should be supplied from the* [Manatee] *river* [community].

A few months later, the paper reported bids were being taken for 324,000 feet of yellow pine to be used in the construction of Fort Dade and that two eight-inch disappearing guns were well on the way to completion. An article in June 1900 commented that the government was seeking bids for boring wells on Mullet and Egmont Keys, and "some of our well borers might find profitable employment by putting in a bid." Clearly, the newspaper considered the building of Fort Dade an economic boost to the area.

According to the December 2003 edition of *Egmont Key Notes*, Sandy Colbert and twelve other volunteers of the Southeastern Geological Society attempted to locate the 360-foot artesian well the army dug in 1911. At first, they could not find it but did notice a definite sulfur odor coming from a spot near the Gulf shoreline. Finally, Barbara Schmidt, a member of the Egmont Key Alliance, a volunteer organization that helps preserve and promote the island, showed them water flowing from the wellhead. Today, the wellhead is underwater, the result of continued beach erosion and demolition of the power plant (built circa 1919) in 1999. It was taken down due to safety concerns, but the rubble can still be seen on Egmont Key's west shore.

Until 1900, the new military installation on Egmont Key was known as the United States Military Reservation at Egmont Key. It was then renamed Fort Dade in honor of Major Francis Dade, who, along with nearly all of his command, died in a Seminole Indian massacre near Bushnell in 1835. Interestingly, Major Dade had gone hunting on Egmont Key in 1824 before the establishment of Fort Brooke in Tampa. Of the key's original 398 acres, 378 became Fort Dade, 15 acres were set aside for a lighthouse and later, in 1928, five acres were leased to the Tampa Bay Pilots Association.

Fort Dade was never a walled fort, but the base grew to hold 70 buildings, mostly wooden, by World War I. In 1900, there were only 100 soldiers,

Fort Dade, 1898–Present

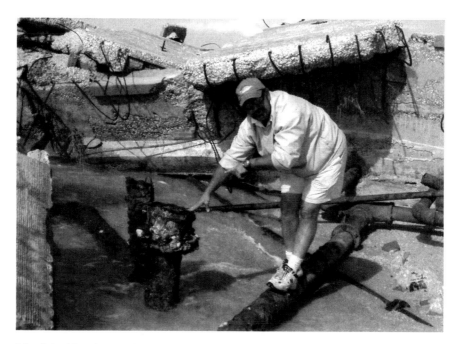

John Schmidt points out fresh water coming from an old well. *Photo by author.*

but in 1905 President Theodore Roosevelt decided to beef up the military base, and the census grew to over 150. Most of the soldiers were young white males, but there were four African American men, five African American women, ten white females and several children as young as three. The African American women mainly worked as servants for the officers or as laundresses for the enlisted men. As was the practice in the South at the time, Fort Dade maintained segregated eating and living quarters for blacks and whites. By 1911, wives and children were allowed to live on the base, and the population increased to 300. During World War I, when Fort Dade became a training center for National Guard Coastal artillery units and antisubmarine crews, 600 soldiers were stationed there. By 1920, the population had declined to 300 again, and after the 1921 hurricane, only a caretaker crew of 18 remained at Fort Dade.

The first soldiers who arrived in 1898 lived in tents, which were replaced with one-story buildings, and by 1909, two-story barracks were constructed. During the hot summer months, the soldiers often slept on screened porches to take advantage of the breeze. By 1919, a power plant on the base supplied electric lights, and telephone service was established well before the general

population on the mainland could boast of such modern amenities. It also had a gymnasium with a movie theater on the second floor, a post office, an icehouse, a thirteen-bed hospital, an elementary school, sewers and roads paved with red brick. These red brick streets and sidewalks were begun as early as 1909, over a hundred years ago. Today, the brick roads are largely intact, although weather and nature have taken their toll. Heavy trucks brought on the island in 1921 when Fort Dade was deactivated also caused some wear and tear. In the 1950s, the U.S. Coast Guard patched some of them, and more recently, the Florida Park Service has cemented some of the loose bricks. More badly damaged spots were filled in with cement and leveled. The brick roads appear to go nowhere in the absence of the former buildings. The sewer system was installed in 1902 and drained into Tampa Bay. Drinking water was supplied by means of cypress cisterns that collected water off the roofs, and water for bathing and plumbing came from six shallow wells.

Besides the aforementioned buildings, Fort Dade also had a mess hall, bakery, morgue and a guardhouse, one of the few cement structures, and the only one intact today. It has been restored. Another cement building was the quartermaster warehouse, built in 1910, but it is in poor condition today. A small garden near the lighthouse supplied fresh vegetables. In 1914, there was a request to establish a dairy at the fort as well. Fishing was plentiful around the island and provided both recreation and another source of food.

Besides the movie theater, base residents could enjoy tennis, a bowling alley and baseball games on Sunday afternoons against teams from the mainland. Baseball was as popular in the early twentieth century as it is today, and during this time period, the *Manatee River Journal* kept readers up-to-date on the games between the soldiers at Fort Dade and the Bradenton team. The August 18, 1910 game was called "the greatest game of baseball played in Bradenton for a long time," with the home team winning 4 to 3 after seventeen innings. The Fort Dade team got its revenge on December 14, 1911, in a "hard-fought" game, football this time, against the high school team, with a final score of 27 to 25. The article predicted that the high school boys' good showing against an older, heavier team would help them win in football games against teams from Tampa and St. Petersburg.

There seemed to be a good relationship between the base on the island and the community on the mainland. Besides ballgames, the Fort Dade band put on concerts for the citizens of Bradenton. The *Manatee River Journal* reported on August 18, 1910, "The military band of Fort Dade will spend this afternoon in Bradenton and in the evening will give a concert at Warren's

Fort Dade, 1898–Present

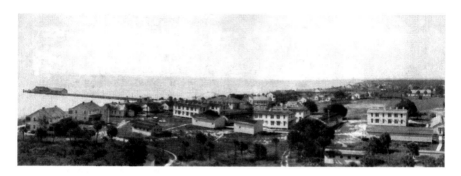

Panoramic view of Fort Dade, circa 1919. *Courtesy of Roberta Moore Cole.*

Opera House during which they will show a series of moving pictures... Captain Clark, the commanding officer at the fort, has arranged for the soldier boys to come to Bradenton Thursdays of each week for a game of ball in the afternoon and concert and moving picture shows at night." The article went on to say the modest admission fees for the show would help defray the balance owed on the instruments. On another occasion, Captain Clark gave a lecture on his army experiences in the Philippines, to benefit the Terra Ceia Library. The base even showed films, and the late Roberta Moore Cole recalled going there to watch a Mary Pickford movie. However, the projectionist took too long changing the reel, and young Roberta fell asleep. The *Manatee River Journal* articles about the base were mostly positive, but that is not to say that everything was always prefect, even back then. On June 5, 1908, the *Journal* reported two soldiers were arrested for breaking into the post office and commissary on Egmont Key.

In 1915, the children of Captain John G. Workizer all attended school at Fort Dade. Laura Jean Workizer Bailey remembered, "The school needed ten children, so even though I was only three, I had to go to school." Her sister, Mary Workizer, recalled she was eight years old when her father became commander of Fort Dade. It did not appear to be a life of any hardship for the family of seven. They lived in a big frame house, with chimneys on both ends and a wraparound screened porch. Their house boasted three bathrooms, four fireplaces and two large cisterns that caught rainwater. The family had a maid and a cook with their own quarters, and the children were taken around by a driver in a three-seat mule-drawn wagon. One time when Mary went out the front door after eating lunch, a huge rattlesnake was stretched out over the front walk. It scared the girls a bit, but Laura Jean never recalled seeing another rattler while they lived on the island.

Captain Workizer was transferred in 1916, and shortly after retiring, he died in the 1918 flu epidemic. By then he and his wife had had four boys and the two girls, but their mother had money enough to buy a home in St. Petersburg. Their father had wisely bought life insurance policies each time a child was born.

A news account from several years before the closure of Fort Dade described a wedding reception held on April 15, 1920. Two hundred people greeted newlyweds Owen and Elizabeth Allen as they returned from their honeymoon. Owen Allen was the manager of the Post Exchange, and he brought his new wife to live on the island for a year. Roberta Moore Cole was there in the crowd and recalled the bride's fashionable skirt was cut so slim she could not get up into the vehicle that had been arranged for them, a flower-bedecked cart drawn by a team of mules, probably the same ones that had taken the Workizer children around. The new Mrs. Allen had to be lifted into the cart. The mules wore blankets, on which "Just Married" was written in large letters. The couple was given a grand reception at their new home, decorated for the occasion with pink and white oleander blossoms.

In the first two decades of the 1900s, there were several epidemics that affected Egmont Key and the nearby mainland. Diseases such as typhoid fever, mumps and scarlet fever hit numerous soldiers at Fort Dade. Today, of course, epidemics are much more rare in the U.S. due to available vaccines and medicines. In January 1903, typhoid fever hospitalized 35 of the 100 men stationed at the base, 9 of whom were in serious condition. None of these diseases could compare in severity with the infamous influenza epidemic in 1918, however. That one was a pandemic, spreading like wildfire around the globe. It is impossible to say with certainty exactly how many people died from the 1918–19 influenza outbreak because record keeping was not consistent or accurate, and communication was not as advanced as today. The death toll has been estimated to have been as high as 30 to 50 million people, and more than 650,000 of those were estimated to have been in the United States. Young people were especially hard hit, and any places with concentrations of people living closely together, such as military bases, were especially vulnerable. At Fort Dade, 236 soldiers were taken ill with influenza between September 25 and November 9, 1918, and an additional 18 were listed as ill with pneumonia. Three more deaths occurred near the end of that year. The Fort Dade surgeon at the time, Captain G.E. Kerr, wrote in a letter to the U.S. army surgeon general about measures being taken to control the spread of influenza: "Cubicles were at once placed in all wards and hospital annexes. All nurses, ward attendants and other persons

coming in contact with patients were required to wear masks, with frequent use of a strong antiseptic solution. All regulations concerning the handling of the disease were complied with."

THE FIVE GUN BATTERIES AND THE MINE CASEMATE

The construction of Fort Dade continued for years as part of an ongoing program of coastal defense. Five individual concrete artillery batteries were built at strategic positions on both ends of the island. As the nineteenth century came to a close, dramatic advances in artillery were achieved. The new weapons could fire heavier projectiles two to three times greater a distance than previously. Many military experts believed the batteries on Egmont Key at the time represented the single greatest advancement in artillery since the invention of the cannon in the fourteenth century.

Because the Spanish-American War had come about so quickly upon the sinking of the USS *Maine*, the Army Ordnance Department found themselves short of artillery with which to defend the seacoast. Accordingly, the army purchased forty-two medium-sized artillery pieces from the W.G. Armstrong Company in England.

Three batteries were built on the north end of Egmont Key to protect the main shipping channel to Tampa. Battery Mellon, the northernmost, had three three-inch guns mounted that were intended to fire at enemy patrol boats and to interrupt mine-sweeping activities by the enemy. When Battery Mellon was built in 1906, the beach was about a hundred yards away. It was named for Captain Charles Mellon, who was killed while fighting the Seminoles in 1837. Just south of Battery Mellon was Battery Howard, which had two six-inch guns and was named for Major Guy Howard, who died in action in the Philippine Islands on October 22, 1899, well after the surrender of Spanish forces in Cuba. This battery was not completed until 1906, and due to a shortage of manpower, gunnery practice was not held there until August 1916. The gun barrels were dismantled a year later and sent to France for use as heavy artillery in World War I.

Just south of Battery Howard was Battery McIntosh, the third and largest built on Egmont Key. At first, it was unnamed but was later given its name in honor of Lieutenant Colonel James McIntosh, who died in 1847 of wounds sustained in the war with Mexico. It had two eight-inch guns with serial

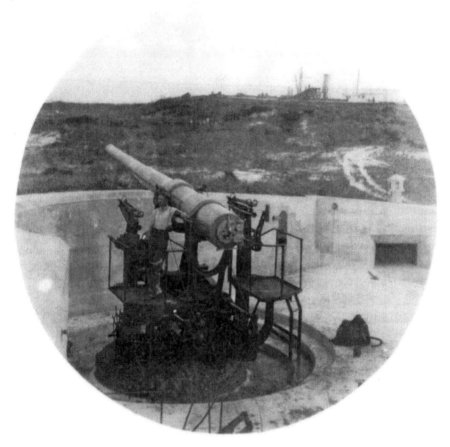

One of two six-inch disappearing guns at Battery Howard, circa 1906–17. *Courtesy of Roberta Moore Cole.*

numbers 001 and 002. They were cast at the Bethlehem Iron Works, later called Bethlehem Steel of Pennsylvania. These rapid-fire breech (end-loaded) guns were installed in 1900 and remained there until Fort Dade closed in 1923. Both McIntosh and Howard Batteries used ingenious disappearing carriages, which utilized the recoil energy of firing. The recoil moved the gun back and down behind the cement parapet wall, out of enemy sight. Once loaded, the guns were raised to fire and then disappeared again.

The earliest battery on Egmont Key was Battery Burchsted, built in 1898, on the south end of the island. It was named for Henry Burchsted, an 1811 graduate of West Point who was killed while fighting the Creek Indians in 1813. It housed 2 6-inch Armstrong guns and 1 3-inch gun. The Armstrong

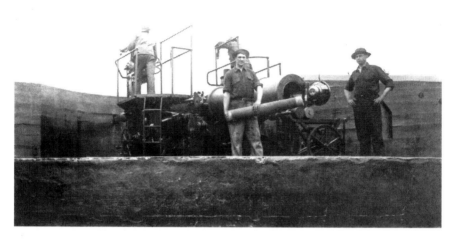

Eight-inch disappearing gun carriage at Battery McIntosh. *Courtesy of Dick Reddick.*

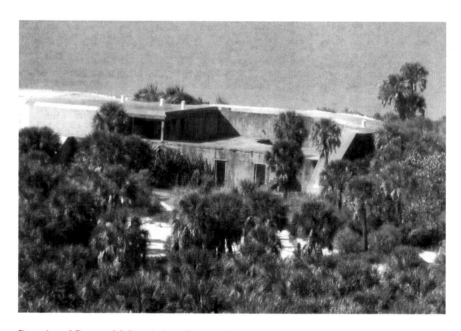

Remains of Battery McIntosh from Egmont Key Lighthouse. *Photo by author.*

guns were breech-loaded and used refillable shell cases that held 13.25 pounds of powder. The projectiles weighed 100 pounds, had a maximum range of 5.68 miles and reached their targets in a little over 28 seconds. Nearby Battery John Page had 2 3-inch guns. It was constructed of Portland cement and sand in 1904, but the guns weren't installed until 1910. It was named after Captain John Page, who was killed in action in 1846 at Palo Alto, Texas. Battery John Page was in operation for only 9 years. All of the batteries were supplied by a three-foot-wide narrow gauge railroad that ran from the quartermaster's dock and also went to the mine wharf and mine casement complex. The munitions and other supplies were sometimes so heavy that soldiers had to push the supply train until it gained momentum. The small porter saddleback steam engine pulled a line of flatcars, one with a searchlight powerful enough to send a beam miles offshore. By 1910, all these batteries were fully armed, and across the northern channel on Mullet Key, Fort De Soto had 8 12-inch mortars and 2 3-inch rapid-fire guns.

Today, both of the southern batteries and part of the railroad right-of-way are underwater, victims of the constant erosion on the Gulf side of the island. In March 1982, the two six-inch cannons were recovered from the collapsing Battery Burchsted. They were restored through electrolysis, a process that uses electronically charged sodium hydroxide to remove corrosion. These cannons can now be seen at Fort De Soto on Mullet Key.

On the north shore, adjacent to Battery Mellon, are the ruins of the "nerve center" complex, or mine casemate building, which housed generators and storage batteries. It was used to electronically set off the mines in the main shipping channel to Tampa Bay. In its early days, this vital control center might have been mistaken for an Indian burial mound, as the western side of the tile-roofed, concrete block building was insulated and protected by an earthen mound. In 1919, the protection was increased by enclosing it with eight-inch-thick walls and a five-foot roof, then covering it with a new mound of sand. The remains that can be seen today show where the mines received their explosive charge in the loading room. Nearby was a building where the electric cables were placed in a freshwater tank to prevent corrosion after being taken out of salt water.

In an interview by Libby Warner in 1988, Carlos Campbell described his experiences about working on Egmont Key for fourteen months, starting in 1917. Campbell recalled:

I helped lay the mines, 19 of them, across from the north end of Egmont Key to Mullet Key. These mines were large round balls filled with TNT

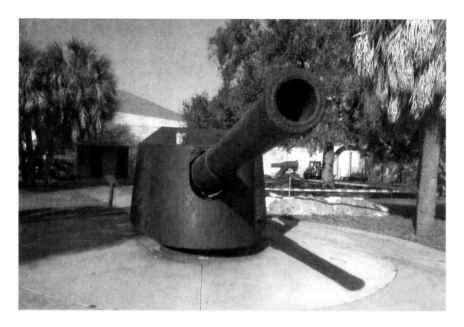

One of two restored six-inch rapid fire Armstrong guns at Fort De Soto, purchased from England in 1898. *Photo by author.*

> *that floated...Each one was tied to the casemate with two electrical wires. On the top of this ball was a cup with a steel ball. If a ship hit that mine and pitched it 45 degrees, the steel ball rolled over and touched a steel ring around the top, and activated the AC current from the casemate and blew up the mine.*

To prevent German U-boats or other vessels from entering Tampa Bay from around the south end of Egmont Key, the guns from Batteries Burchsted and Page were trained on the southern channel.

After the construction of the lighthouse and the start of Fort Dade, steamboat excursions often brought visitors from Tampa and St. Petersburg to visit the lighthouse keeper's house and to view the progress of the construction of Fort Dade. In July 1894, an informal open house was held for visitors at the newly built military reservation. Local people were very interested to see what was going on. The May 4, 1911 edition of the *Manatee River Journal* announced that bad weather forced the postponement of excursions and big gun practice from April 24 to May 6 and that the boat would leave at 7:20 a.m. and return in time to

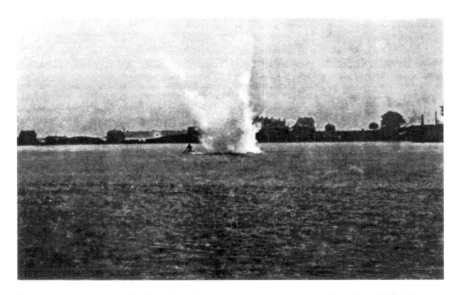

Postcard showing an exploding submarine mine during target practice, circa 1917–18.
Courtesy of Roberta Moore Cole.

Wives and families of Fort Dade and lighthouse communities at the airstrip on the bay side
of Egmont Key, circa 1917–18. *Courtesy of Roberta Moore Cole.*

connect with the train to Sarasota and Oneco, which suggests that people came from farther away to these events. In May 1911, the *Tampa Tribune* reported, "A special Favorite Line excursion came to Egmont so sightseers could witness the Coast Artillery men practice shooting at stationary and floating targets." It went on to say that targets five miles away were hit and world records were broken. The Favorite Steamboat Line advertised, " A chance in a lifetime! Let the children see what Uncle Sam is doing." How times have changed!

In spite of the numerous practices and simulated combat drills held on the island over the years, the guns on Fort Dade were never fired against an enemy. In the early twentieth century, they were only fired at practice targets towed out into the Gulf. Word would go out by telephone: "All is in readiness." Within half an hour, firing would start and last about 20 minutes. Roberta Moore Cole recalled, "Everybody would check that all of their china and cut glass were secured, that cotton was stuffed in their ears, and the windows were closed. Then it was time to huddle as the loud, hateful noise began!"

Fort Dade possessed its own airstrip along the beachfront on the bay side of Egmont Key. It was a temporary runway for spotter aircraft, and the runway was nothing more than a flat cleared section of beach. There were no hangars or other aircraft facilities.

As previously discussed, in 1900 Fort Dade had some of the most advanced artillery guns, but by 1917, guns on ships had a better range than Egmont's old guns, which made the coastal batteries obsolete. Some of the guns were removed and taken to the European front, since the threat of naval attack on Tampa Bay had been deemed less likely. By 1920 the prevailing military opinion was that mobile artillery was effective for coastal defense, so on August 31, 1921, Fort Dade was deactivated. All personnel except for a fifty-member caretaker unit were transferred to Key West. About two months later, on October 25, 1921, Egmont Key was hit by the area's second worst recorded hurricane. The entire island was underwater, and about seventy-five people took refuge in the lighthouse. Because of this hurricane and several others that followed, the garrison was reduced to eighteen. By May 1923, Fort Dade was left in the hands of one caretaker, Sergeant Fagan.

THE YEARS AFTER FORT DADE CLOSED

During the Prohibition era, when the manufacture and sale of alcoholic beverages became illegal in the United States, bootleggers attempted to smuggle liquor into the country any way they could. Most of the buildings on Fort Dade were abandoned in the mid-1920s, so smugglers saw an ideal opportunity to use the former military base for their illegal liquor import business. Federal agents learned of this operation and prepared to round them up. The Feds found sixty-five cases of liquor but no smugglers, as they'd seen them coming and were hiding in the underbrush during the raid. The agents then decided to flush them out by setting the dry grass on fire. The bootleggers were successfully smoked out of hiding and taken to Tampa. The federal agents attempted to put out the grass fire, but brisk winds reignited the embers. At least fifteen former Fort Dade residences and other buildings were destroyed. Only the heroic efforts of the base caretaker, Sergeant Fagan, and about thirty volunteers working tirelessly without even stopping to eat, saved the rest of Fort Dade.

The rest of the 1920s and the 1930s were a period of uncertainty for what remained of Fort Dade. In 1929, there were plans to reactivate the base with 240-mm howitzers, but this never happened. In May 1931, Fort Dade and Fort De Soto went up for sale for $387,000, but there were few offers given the Depression's hard economic climate. Egmont Key was eventually passed to the Treasury Department.

In the time between the two world wars, the Coast Guard built a small arms firing range with concrete walls. Coast Guard crews competed both on the island firing range and from their ships, firing at targets in the Gulf. Some crew members were quartered at the barracks on Egmont Key, and the rest lived aboard ship. The former ice plant was converted into a mess hall, where hot meals were served during the 1930s. The remains of this building are now underwater.

In 1933, the War Department removed the caretaker, leaving the Coast Guard, Tampa Bay Pilots and the lighthouse keeper in charge of Egmont Key. Between 1935 and 1936, four fires on the island prompted the Coast Guard to request permission to level many of the remaining wooden structures left from Fort Dade since they were a fire hazard. Hurricanes during the 1930s also caused much damage to the buildings. By the time America entered World War II, Fort Dade's structures were mostly gone.

Front page headline from the April 25, 1925 edition of the *St. Petersburg Times. Collection of the St. Petersburg Main Library.*

In the fall of 1930, the Coast Guard health officer began to assess ways of eliminating the large mosquito population that made life nearly unbearable during the summer. Until this was dealt with, the Coast Guard could only use the rifle range during the winter, when the mosquitoes inhabiting the salt marsh on the island were less active. If the breeze was from the Gulf, there were fewer mosquitoes, but a breeze from the mainland brought hordes of the bloodthirsty little insects. All the buildings were screened, and a common practice was to brush one's clothes with a palm frond to remove as many mosquitoes as possible before entering a building. During World War I, soldiers wore hats with veils that fell to their shoulders to protect their heads and necks from mosquito bites.

Egmont Key During World War II

With the United States' entry into World War II, Egmont Key experienced a rebirth. The U.S. army again took over both Egmont Key and Mullet Key to train troops. The War Department cleared roads, repaired the existing structures and erected new ones. They used the rifle range on the Gulf side of Egmont Key (now underwater due to erosion). Even today, brass bullet casings occasionally wash up on the beach in this area. These typically are marked, indicating the caliber and the year, and the ones found may be from either World War I or II. The east end of the Mullet Key was used as a bombing range from 1940 to 1946 for aircraft based at McDill Field south of Tampa.

At first, it was the U.S. Coast Guard and the Tampa Bay Pilots, many of whom became lieutenant commanders in the Coast Guard Reserve, that checked every ship going in or out of Tampa Bay for their papers and consigned cargo. By 1943, Egmont Key became a harbor patrol station run by the Navy. It oversaw the offloading of ammunition from ships for storage in the ammunition magazines already on the island from Fort Dade. When the ships prepared to go out into the Gulf, the ammunition would be reloaded again. Work details hacked away the jungle that had grown up around the abandoned Fort Dade gun batteries and cleaned out debris. The former Fort Dade icehouse was again turned into a mess hall for the Coast Guard, and later army and navy personnel.

At full strength, sixty Coast Guardsmen maintained the lighthouse, radio station and, with help from the Tampa Bay Pilots Association, patrolled the area. They were later joined by sixty naval personnel attached to Harbor Entrance Patrol and thirty-five army troops in charge of coastal artillery. These men performed aerial gunnery exercises and practiced amphibious warfare training.

Coast Guardsman Cecil. E. Kirkham related his time in Egmont Key:

I was alone in this [Coast Guard] *tower for an eight-hour tour of duty... and watched for any* [Nazi] *ships and planes that appeared on the horizon* [using his Bausch and Lomb binoculars]*....Nazi submarines were all about in coastal waters at this period and sinking Allied shipping in mass...This was my duty and rather pleasant all in all, perched here atop the 40-foot Coast Guard tower.*

Eventually there were three lookout towers on Egmont Key, and the Navy signal station was added to the top of Battery Mellon on the northwestern portion of the island.

Between October 1942 and November 1943, the entrance to Tampa Bay at Pass-a-Grille and Egmont Key was designated as the Temporary Harbor Defenses of Tampa Bay. Pass-a-Grille was chosen due to its location about five miles north of the main shipping channel and because it was also connected to the mainland by a bridge, making supply and logistical support much easier. This area was fortified as follows: from Third Avenue south to Pass-a-Grille Point, four 155-mm guns and .30 caliber antiaircraft machine guns were set up in sand-bagged emplacements manned by an Army company; a powerful 800-million-candlepower portable Sperry-type searchlight was set up to spot enemy planes or ships; and 256 prefabricated "hutments," each housing 6 to 8 men, were erected for enlisted personnel. Additionally, several searchlights were erected on Egmont Key atop the abandoned gun batteries. On the beaches of both Egmont Key and Pass-a-Grille, a detachment of the Fifty-Third Coastal Artillery set up camouflaged machine guns. Amphibious vehicles practiced landings on Egmont Key.

All these military defenses and activity had an effect on the local population. During World War II, the government required commercial fishing boats to carry identification cards with photos if they wanted to go beyond inner coastal waters to fish. A local resident, John McDonald, now a volunteer at the Florida Maritime Museum of Cortez, recalls his father, Luther McDonald, was captain of a commercial fishing boat that was stopped near the main channel between Egmont and Mullet Keys. At that time, fifteen to twenty Coast Guard launches patrolled the Gulf, looking for suspicious activity and checking boat identification. John was a small boy at the time, and if they were stopped, he and his brother would quickly hide under the bow, since they didn't have identification papers. His father's boat often fished for mullet near Egmont Key, and he recalls that during the years 1939 to 1948, the cannons were still at the two batteries overlooking the south entrance to Tampa Bay. Sometimes when his father brought up the nets along the Longboat Key coastline, they'd find what appeared to be a bomb in the net with the fish they had caught. Planes from what is now the Sarasota-Bradenton Airport used the central Gulf coastline off Longboat Key as a bombing range during World War II, as was done along other shorelines in Florida. Between 1940 and 1946, the Air Force used the eastern end of Mullet Key and Passage Key in a similar fashion, for aircraft from McDill Field south of Tampa and Drew Field in Sarasota. The

planes shot live ammunition across the main shipping channel. A red flag on the bombing range meant a ship was about to enter the channel, and the planes would cease firing. Sometimes bullets fired from B17s or P40 planes ricocheted off the water and hit a plane's radiator, causing engine failure. The pilot would have to be rescued before the plane sank.

Even though the guns at Egmont Key were never called upon to defend Tampa Bay against a wartime enemy, history shows that enemy boats were occasionally present in nearby waters. Nearly forty U.S. ships were sunk off Florida coasts. On November 1, 1943, a German submarine was sighted just 18 miles southwest of Egmont Key. A U.S. blimp had spotted the enemy sub and radioed to the USS *Nunzer*, at the time on its shakedown cruise out of New Orleans. The blimp and submarine played a cat-and-mouse game, the blimp keeping close track of the submarine and informing the *Nunzer* of its position. In its very first taste of battle, the *Nunzer* sent 144 depth charges and 120 hedgehogs, set to explode at 25, 50 and 75 feet, against the German submarine. It made short work of the vessel, which sank. Two German survivors, one of whom spoke English, were found clinging to a raft the next morning. The English-speaking submariner repeated over and over, "They were damned persistent!"

In September 1958, professional salvage diver Jim Hall used LORAN, a navigational system, to find the German submarine and went down to examine the remains resting on the Gulf floor. It was found twenty miles from the Egmont Key "whistler" buoy, in eighty-four feet of water. During the dive, Hall also found another submarine wreck, an old World War I German U-boat that had been in Tampa, was towed to sea and went down off Egmont Key. Initially, Hall had thoughts of salvaging the valuable mercury from the wreck but then feared it might be booby-trapped, or that he and his crew might be charged with the responsibility for any bodies still inside. Hall mentioned finding the submarine to a coworker, Haris Taylor, who told him he had been a member of the *Nunzer* crew during the attack on the German U-boat. The proximity of the wreck and the location of the original attack seem to confirm that the submarine Hall found and the one Taylor remembered attacking are the same.

As enemy danger to the coastline diminished, the army was ordered to abandon Pass-a-Grille and Egmont Key. The troops stationed there "were likely going from Paradise on Egmont to overseas combat," according to Cecil Kirkham. This was followed by the Navy's withdrawal and the cessation of beach patrol by the Coast Guard. Egmont Key returned to its quiet existence, although still under the Coast Guard's watchful eye.

Fort Dade, 1898–Present

Egmont Key was again used for training during the Korean War and during the Cuban Missile Crisis. In November 1962, 850 men of the First Armored Division invaded Egmont Key. This landing exercise was a joint Army-Navy endeavor. During the combat simulation, TNT and machine guns were used, and light observation planes flew overhead, simulating airstrikes on enemy forces. During the 1970s, the Marine Corps Amphibian Battalion also practiced landings on Egmont Key's beaches. According to the *St. Petersburg Times,* on April 15, 1977, the Marines undertook their annual cleanup project after completing military maneuvers, removing debris and trash from the three-and-a-half-mile-long island. A 1978 mock battle included amphibious tanks, reconnaissance planes, helicopters and about 180 personnel.

Given its geographic location, it is possible Egmont Key may once again become the site of military operations of some kind, but at the present time, it has no military connections. Today, Egmont Key exists as a state park, a national wildlife refuge, a base for the Tampa Bay Pilot boats and a popular beach stop for boaters.

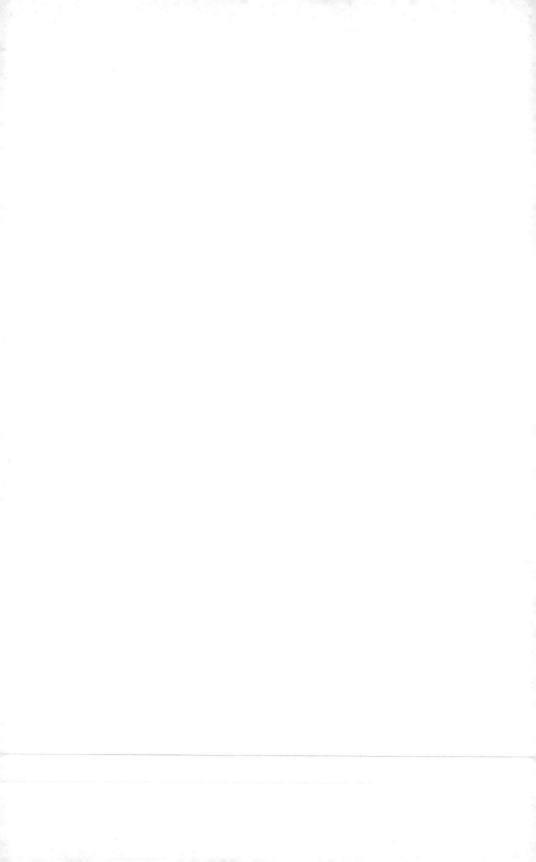

THE TAMPA BAY PILOTS

The profession of ship pilot is one of the oldest, dating from Biblical times. The Old Testament Book of Ezekiel, 27:8 refers to "wise men" who were ship pilots at Tyre. Homer's *Iliad* and the journals of Marco Polo also mention ship pilots. The first pilots to navigate Tampa Bay were members of Spanish explorations. Pilots were deemed so important by the Spanish that they were the most highly paid crew members after the captain. Samuel Clemmons, author of *Tom Sawyer*, adopted his pen name Mark Twain from his days as a Mississippi River boat pilot from the phrase "mark twain," which was a depth sounding of two fathoms, or twelve feet.

In the mid-1800s, Tampa was a small city with a channel twelve to fourteen feet in depth in shallower places, with some areas considerably deeper, winding its way past Ballast Point to Tampa. As traffic on this waterway from Egmont Key increased, so did the need for pilots with knowledge of the shipping channels, tides and underwater hazards so ships could be safely guided into port. In April 1848, the county commissioners for Tampa appointed two pilots, who were to be paid according to the ship's draft. A few years later, in the 1850s, a pilot could be picked up at the lighthouse on Egmont Key. In the early to mid-1880s, prior to the organization of the Tampa Bay Pilot Association, small steamers often stopped on the bay side of Egmont Key to borrow a chart of Tampa Bay from senior lightkeeper Captain Charles Moore. After making port, the steamer would stop on its way back to return the charts for use by the next ship.

Loading phosphate at Port Tampa. Passengers on Henry B. Plant's steamships stayed at the hotel on the right. *Author's collection.*

After several mishaps in the shipping channel, the Tampa Bay Pilots Association was formed in 1886, when its first collectively purchased pilot boat, the *Gulnare*, was built. They requested permission to build a lookout tower and dwelling on the lighthouse grounds, and by 1893, the forty-four-foot tower was completed. At that time, ten steamships and sailing vessels were regularly entering Tampa Bay to load phosphate, an export product still in demand today for use in making fertilizer. In early 1888, Henry B. Plant built Port Tampa as a terminal for phosphate export, as well as for a port of call for his steamships, *Mascotte* and *Olivette*, which traveled to the Caribbean and as far north as Nova Scotia. On May 20, 1901, the Tampa Bay Pilots Association received a license to maintain a small wharf, a pilot lookout and four small dwellings on the land they had leased. The Palmetto Ice and Power Company received permission to construct and maintain a small icehouse on October 15, 1903. By the following year, there were six pilots and a harbor master. In 1911, John J. Fogarty, a member of the Tampa Bay Pilots Association, was granted a license to build a four-room cottage in the pilots' community.

According to Geoffrey Mohlman, "Before 1912 pilots stayed at the lighthouse keeper's, waiting for ships to arrive. On February 17, 1912, the federal government permitted the Tampa Bay Pilots Association to lease several acres of land on the southeast side of Egmont Key to maintain a lookout for ships and home for the pilots." Captains H.G. Warner and

Pilot station lookout tower on Egmont Key, postmarked November 21, 1916. *Courtesy of Roberta Moore Cole.*

W.A. Switzer were the first pilots at the new pilot station on Egmont Key. Once a ship was spotted from the lookout tower, a pilot would set out in a small sailing sloop to board the incoming vessel and guide it into port. At first, Captain Switzer was responsible for all incoming ships, while his partner Captain Warner guided the ships back out of port. By 1914, Florida's legislature passed Act 1293, which provided eight pilots to guide ships in and out of St. Petersburg, Tampa and Manatee. In 1916, the depth of the channels was increased from twenty-four feet to twenty-seven feet, which improved shipping. A government publication advised pilots in 1916 that the first object usually seen on Egmont Key was the 130-foot water tower, located three-eighths of a mile south of the lighthouse. At that time, the lighthouse had a white fixed light visible for fifteen miles. In 1928, Hillsborough County purchased 5.5 acres on the southern bay side of Egmont Key for a purchase price of $3,850, which the county leased to the Tampa Bay Pilots Association.

According to the association rules, each pilot was required to build a cottage on Egmont Key, even if he already owned a home in Tampa. Eventually, about eighteen houses were built at the pilot compound, which also had a 300-foot pier, lookout tower, fuel storage tanks, emergency generators and radio communication equipment. Often pilots began their careers as boys as young as ten, serving first as a lookout in the watchtower and later moving up to become a pilot by the time they were adults.

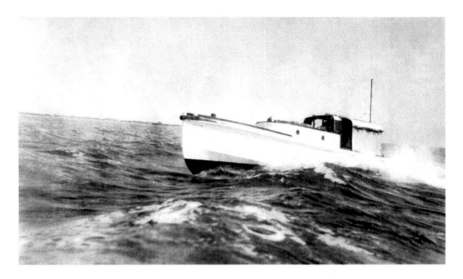

1940s-era pilot boat. *Courtesy of Roberta Moore Cole.*

In October 1921, a devastating hurricane swept away some of the channel markers, which were replaced by temporary ones. However, on February 6, 1922, the Tampa Bay Pilots Association petitioned the Department of Commerce to replace these channel markers with permanent beacons, stating the temporary ones were "entirely inadequate, being too low and can only be seen at a limited distance." The Association went on to comment that thus far there had been no serious mishaps but "it is only conjecture as to when some vessel is likely to get into serious trouble, thereby greatly damaging the commerce of the port."

During the late 1800s, there was surprisingly little interaction between the lightkeepers and their pilot neighbors because they were all so busy with their own duties and responsibilities. But by the 1930s, the lightkeeper picked up mail at the pilot station (the old Fort Dade post office no longer existed by that time). Lightkeepers would sometimes get a ride on a pilot boat to the mainland to pick up supplies or do other errands.

The Tampa Bay Pilots continue to guide ships in and out of Tampa Bay, but pilots no longer live permanently on Egmont Key. The cottages are used mainly by the pilots for rest between ships. There are currently twenty-four pilots in 2012. Becoming a harbor pilot is not an easy task. The first step is to obtain the required license, usually by spending four years in a merchant marine academy and going to sea for a minimum of five to eight years as an officer to gain the experience and qualifications to be

eligible to take the entrance exam. When a position becomes available, all qualified applicants sit for an extremely comprehensive two-day test, which includes drawing all the charts, channels, buoys, markers and navigational hazards from memory. The applicant with the highest test score is accepted into training. The training itself is long and rigorous, with nine levels. It usually takes three or more years to complete. Once the training has been completed, pilots work two-week shifts, with two weeks off in between shifts. Pilots are well compensated, but most people probably don't realize they have a risky, dangerous job and a huge burden of responsibility, so the salary is well earned. Pilots work in all kinds of weather and often in adverse conditions—rain, gale winds, storms, rough seas, fog and poor visibility—while maneuvering a huge vessel through narrow channels. The vessel itself may be old and in poor condition, adding to the difficulty. Two pilots have lost their lives while boarding ships in inclement weather during the last twenty years. The trip from west of the Sunshine Skyway Bridge to the Port of Tampa extends for forty-five miles and takes on average five hours. This route is twice as long as the route into the Jacksonville port, the next longest route in Florida.

Tampa Bay's ports are extremely busy. About four hundred ships per month pass through the main shipping channel north of Egmont Key. A wide variety of products are shipped out, including phosphate, fertilizer, scrap metal, citrus fruits and vegetables. Major imports coming into Tampa Bay are petroleum products, ammonia, potash, sulfur, lumber, bananas and automobiles. In addition, numerous cruise ships sail in and out of Tampa. However, since 2008, the economic slowdown has decreased demand for cement and lumber, which in turn has caused a decrease in the number of ships going in and out of Tampa Bay the past several years.

Ships carrying hazardous cargo, such as anhydrous ammonia (used in processing phosphate to make fertilizer), are required by Coast Guard regulations to be the only ships within their sections of the navigation channel while they are transiting. Often hazardous cargo vessels and cruise ships are escorted by U.S. Coast Guard vessels with flashing blue lights to warn off small boats from these "special cargo" ships. Fees for freighters traveling the forty-five-mile-long channel into Port Tampa are determined by the ship's draft (its depth in the water) and its tonnage. It might cost a cruise ship $5,000 to be piloted one way, for example.

Only constant dredging keeps the shipping channels open to the necessary depth. Ship captains and pilots alike must be constantly aware of the strong currents. With years of experience, pilots learn the particular demands of

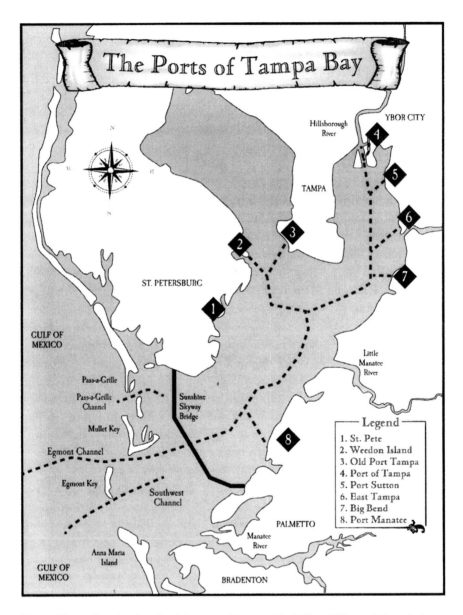

Map of Tampa Bay showing the eight ports. *Map created by Melissa Williams of Steam Designs.*

each route to one of the ports, so an effort is made to keep a particular pilot assigned to the route he knows best. The following paragraphs describe a pilot's typical routine.

A pilot boat will leave the pilot station and bring the pilot out to the sea buoy, also known as the "whistler." It is the farthest seaward buoy, 14.4 miles west of Egmont Key. Some freighters wait at anchor at this buoy until there is room at one of the eight Tampa Bay ports. (These include the Port of St. Petersburg, Weedon Island, Port Tampa, Port of Tampa, Port Sutton, East Tampa, Big Bend and Port Manatee. Weedon Island and Big Bend are sites of power stations.) When a pilot boat reaches the freighter, it pulls up along the starboard side and the pilot climbs a rope ladder to the freighter's deck. In the early 1990s, Tampa Bay harbor pilot Captain John C. Timmel recalled his experiences climbing up the "Jacob's Ladder" onto ships, in all kinds of weather, often with the vessel pitching from one side to the other. According to an article printed in the *Bradenton Herald*, "He banished memories of two experienced pilots who died climbing up the 'Jacob's Ladder.'" One suffered a fatal heart attack, and the other slipped and fell into the water between the ship and the pilot boat. By the time the pilot reaches the wheelhouse, the pilot boat is already on its way back to the pilot station on Egmont Key.

While the freighter is still approaching the whistler buoy, the pilot is escorted to the bridge of the ship, where he meets the captain and takes over the piloting of the vessel. The pilot is usually the first person to come in contact with the captain, so he often becomes a sort of ambassador of good will and a one-man welcoming committee, offering advice and information concerning speed, courses, placement of tugs and so forth, but the captain remains in command of his ship. The pilot gives directions to the shipmaster, or captain, and, as the ship progresses, the pilot gives course changes to remain within the channel. When the largest of the cruise ships pass beneath the Sunshine Skyway Bridge, the pilot must make sure the ship is perfectly aligned with the channel centerline.

As the pilot finally guides the ship into the port, he calls in tugboats to assist in docking the ship. Once the ship is safely alongside the dock, the pilot's job is finally finished. After the cargo is loaded or offloaded and supplies are brought aboard, the ship is ready for another pilot to board and guide the ship back out into the Gulf of Mexico. Before it can leave, of course, the ship will have to be turned 180 degrees with the bow heading out. The outgoing pilot will then carefully guide the ship back to sea and will be met by the pilot boat when his job is finished. Then he'll return to the pilot station.

Pilot boat at Egmont Key pilot station, 2010. *Photo by author.*

Pilot boat following freighter past Egmont Key to the Gulf of Mexico, 2010. *Photo by author.*

Pilot leaving a Carnival Cruise ship after guiding it into the Gulf of Mexico, 2005. *Photo by author.*

As mentioned previously, pilots are highly experienced and have undergone long and rigorous training to make good judgments and prevent accidents. However, in spite of skill and training, conditions occasionally create hazards that result in tragedy or disaster. On May 9, 1980, the freighter *Summit Venture* was blown out of the channel by seventy-knot winds in a blinding rainstorm and ran into a span of the old Skyway Bridge. The pilot tried to compensate for what was happening, but it was too late to sufficiently change course. At thirteen knots, it generally takes a large ship at least ten minutes and more than a mile to stop. Unfortunately, thirty-two lives were lost in this accident. Authorities later exonerated the pilot, calling the disaster "an act of God." Today, pilots operate with GPS navigation systems that can largely prevent accidents such as this one.

In the 1990s, it was estimated five billion gallons of oil move through Tampa Bay to various ports each year. In August 1993, the freighter *Balsa 37* and two barges collided early in the morning, two and half miles west of the Sunshine Skyway Bridge. There were no injuries, but the collision created an environmental disaster, dumping number 6 fuel oil and jet fuel in the waters just north of Egmont Key. The oil spill adversely impacted birds and newly hatched sea turtles on Egmont Key, but authorities thought it could've been much worse. The outgoing tides, the winds and a strong thunderstorm spread the spill fifteen miles west, away from Egmont Key.

Recently, there has been growing concern about the need to prepare young people to fill the increasing demand for maritime workers in the Tampa Bay area. It is estimated maritime jobs will grow 15 percent by 2018. Until recently, not much has been done to prepare future workers for these jobs, even though the median age of current maritime workers is forty-three, and the Tampa Bay area is home to Florida's largest port. To address this concern, Blake High School in Tampa has inaugurated a Maritime and Marine Academy. Students are introduced to more than 150 area companies that employ 16,000 workers in such maritime-related jobs as ship's pilot, ship repair, the cruise industry, container sales, admiralty law, salvage and dive operations, environmental engineering, tugboat operations, security, ship chandlers and the like. Students in the program who are seniors in high school can participate in internships.

The planned completion of the widening of the Panama Canal in 2014 will bring increased numbers of freighters and container cargo into Tampa Bay ports. In order to prepare for and profit from this increase, a fifty-two acre container yard is being planned at the Port of Manatee, the closest U.S. port to the Panama Canal. Also at Port Manatee, three additional docks will

Huge cranes unloading fruit from a cargo ship at Port Manatee, 2012. *Photo by author.*

be built over a ten-year period to accommodate ships bringing fruit, lumber, aluminum and stone aggregate used in building roads. The Port of Manatee currently has 207,000 square feet of refrigerated warehouse space, more than any other port on the Gulf of Mexico. It is also the largest import site for South American lumber products in the Southeast. The Port of Manatee has a $750 million master plan that includes proactive environmental mitigation, dredging and berth expansion, new container terminals and other improvements. With all the anticipated activity at this one port alone, it seems likely that the Tampa Bay pilots will continue to play a vital role in the Tampa Bay shipping industry.

PRESERVING EGMONT KEY'S WILDLIFE AND PLANTS

There have been many environmental changes on Egmont Key since Major Francis Dade first came to Egmont Key to hunt deer in 1834. Dave Ferdon, a park ranger on Egmont Key during the 1990s, once commented that the island is a kind of mini-Galapagos that allows visitors a glimpse of Florida's coastal ecology in miniature. At various times, Egmont Key has been used for military purposes, but now it sees park rangers, members of the Tampa Bay Pilots Association and day visitors who arrive by ferry from Fort De Soto or from private boats anchored offshore. The military base of Fort Dade grew into a bustling community of over six hundred for a relatively short time during the World War I era. All that remains of the community are orderly red brick roads and the remains of cement foundations to mark where the seventy wooden buildings that comprised Fort Dade once stood. After Fort Dade was closed, the buildings were demolished by hurricanes or destroyed in fires.

GOPHER TORTOISES, LOGGERHEAD SEA TURTLES AND REPTILES

Today, the only inhabitants likely to be spotted, besides the rangers and pilots who may be staying on the island, are gopher tortoises ambling across

the roads at a leisurely pace. An estimated 2,000 gopher tortoises live on the island. Over the years, they have done well in a habitat that includes wire grass, flat woods and coastal dunes. Gopher tortoises (*Gopherus polyphemus*) belong to a family of land tortoises that have been in North America for 60 million years. At one time, there were twenty-three species, but that number has dwindled to just four surviving today. The slow-moving gopher tortoises have declined elsewhere due to many factors, including loss of habitat and disease, but they are thriving on Egmont Key. This was not always the case, as during the Great Depression of the 1930s, before Egmont Key was protected, people hunted them for food and considered "Hoover chickens" a tasty meal. Even as late as Labor Day, 1964, the Pinellas Park Boys Club held its annual gopher tortoise race, for which the youngsters rounded up the tortoises. One can only imagine the probable destruction to the burrows and surrounding habitat, not to mention the possible trauma to the tortoises! Should Egmont Key ever lose its park and wildlife refuge designations, it is possible the tortoises could be adversely affected, as some people still consider turtle stew a delicacy. Fortunately, in Florida the gopher tortoise is on the endangered list.

Gopher tortoises are mainly herbivores, subsisting on native sea grapes, pear cacti, porter weed, paw paw, fig leaves and other plants. Their most preferred food, though, is grass, so some biologists think of them like cows with shells. As they graze, they spread plant seeds. They are also opportunistic and will sometimes eat dead animals. Gopher tortoises are seldom seen actually drinking water and get most of their water through the plants they eat. However, during heavy downpours, they are occasionally spotted taking advantage of the rainfall and drinking.

According to records kept by the park rangers, many newly hatched gopher tortoises and box turtles have been observed in recent seasons, but their habitat is decreasing due to erosion on the Gulf side of the island. Visitors are encouraged to keep away from their burrows, which can be six to ten feet in length and as deep as ten feet. As many as three or four live in one burrow, along with other wildlife such as snakes, lizards and frogs. Gopher tortoises have been seen using their flipper-like front legs to dam up the burrow entrance during a rainstorm. Mature gopher tortoises average about ten to fifteen inches long and weigh twelve to thirty pounds. Females take ten to fifteen years to reach maturity and will lay between four and seven eggs. The eggs are usually found on the apron of the burrow, another reason for humans to keep away from the tortoises' homes. The mature tortoises have elaborate courtship habits and nest between April and July.

One of Egmont Key's many gopher tortoises. *Photo by author.*

The young hatch within ninety days. Interestingly, the sex of the young turtles is determined by the temperature of the sand; a temperature below 80 degrees produces males while a temperature above 85 degrees produces females. If the hatchlings survive their first precarious months of life, they can live for well in excess of fifty years, especially on Egmont Key, where there are no natural predators. Wildlife experts record the age of gopher tortoises by notching their shells.

Besides the resident gopher tortoises, another creature that can be found on Egmont Key at certain times of the year is the loggerhead sea turtle. These large turtles come ashore on the island to reproduce. The females leave "tractor trails" as they claw their way up from the water and along the beach to dig a hole and lay their eggs and then lumber back to the water, leaving the eggs and hatchlings to their fate. Most female sea turtles return to within five to thirty-five miles of where they were hatched to lay their eggs. Male sea turtles generally do not leave the water. Like gopher tortoises, the sex of the young loggerhead turtles is determined by the sand temperature. After fifty to sixty-five days in their sandy cradles, the young turtles tear open their papery shells and make their way to the surface. The hatchlings wait for the cue of cooler temperatures at night, when predators are less active, and crawl seaward, toward the lighter horizon over the Gulf. Unfortunately,

Tracks left by a female loggerhead sea turtle making her way onto the beach to lay her eggs. *Courtesy of Egmont Key Alliance collection.*

the hatchlings' journey to the sea is sometimes disrupted by artificial light sources along the beach, such as streetlights or porch lights. The disoriented babies move inland by mistake, dooming them to exhaustion, dehydration and attacks from predators. For this reason, nighttime lighting along beach areas known to be sea turtle nesting grounds is discouraged by wildlife experts during turtle nesting season (which usually runs from May until the end of September). It is estimated that only 1 in 1,000 sea turtle hatchlings survives to adulthood.

In August 1993, a freighter and two barges collided in the shipping channel between Egmont Key and Mullet Key. The resulting spill of 336,000 gallons of heavy sludge-like oil "could not have happened at a worse place or time," according to Richard Eckenrod, executive director of the Tampa Bay National Estuary Program in St. Petersburg, Florida. The mangrove and saltwater marshes to the east of Egmont Key provide breeding grounds

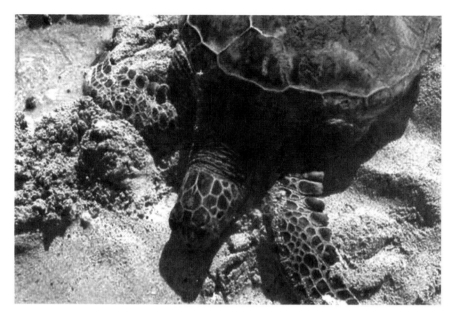

Female loggerhead turtle laying eggs on the beach. *Courtesy of the Egmont Key Alliance collection.*

for snook, shrimp and crabs. As luck would have it, the oil spill was driven west of Egmont Key by outgoing tides, winds and a strong thunderstorm, sparing the fish nurseries, but the impact was felt on Egmont Key. The oil slick covered portions of the east shoreline and all of the north shore of the island. The sea turtle nesting season was at its height, with baby turtles hatching and ready to go into the water. Volunteers and park officials spent a night covering turtle nests with special wire cages to prevent the hatchlings from crawling into the oil-coated water of the Gulf. The Egmont Key State Park manager, Bob Baker, and his wife, Betsy, rescued 57 newly hatched sea turtles before dawn and released them into clean water.

In May 2005, the Sea Turtle Index Nesting Beach Survey Project was begun. This scientific survey records numbers of nesting turtles and hatchlings each year. Interns from Eckerd College are often hired through grants to help monitor the turtles, under the supervision of the park manager. Most years, about twenty-five loggerhead nests are confirmed, but some are lost every year when storms wash them away. A red tide outbreak will sometimes occur and sicken or kill sea turtles and cause massive fish kills, which in turn affect birds that feed upon the fish. A few lucky turtles can be nursed back to health. Many years "false crawls" occur; loggerheads come out of the water

and onto the beach but return without laying any eggs. This is sometimes aggravated by obstructions on the beach that prevent the turtles from coming far enough onshore. Additionally, erosion has caused palm trees to collapse onto the beach, obstructing the turtles' path. Volunteers from the Egmont Key Alliance help remove palm trunks or other debris so the sea turtles can reach nesting spots far enough above the waterline to keep their nests from washing away in the tide.

A small reptile commonly found on Egmont Key is the native green anole (*Anolis carolinensis*). Some people refer to these as American chameleons because they can change color from light brown to green. The nonnative Cuban brown anoles can be brown, black or a combination of these colors. Both species are difficult to spot due to their ability to blend in so effectively with their surroundings. Anoles eat a variety of insects. The breeding season is from early April until late August. The male performs an elaborate display to attract a mate, extending his brightly colored dewlaps while bobbing and dancing. The female lays up to ten eggs in soft soil and departs, leaving the eggs to incubate for forty days and hatch on their own, with no care from either lizard parent.

Early residents reported numerous encounters with snakes, including large rattlesnakes. As mentioned in Chapter 6, Roberta Moore Cole, who spent her early childhood on Egmont Key, described her father killing a huge rattlesnake while she was playing in their yard. It is believed that few, if any, rattlesnakes still exist on Egmont Key today, a result of both the feral cats eradicating the snakes' natural prey and deliberate removal of any found when the bird sanctuary was created. However, there are quite a few harmless black racer snakes still on the key. These swift, agile snakes commonly prey upon lizards, mice and birds' eggs.

SEA LIFE IN EGMONT KEY WATERS

The waters around Egmont Key teem with many species of fish. On the Bay side of Egmont Key, sea trout, redfish and ladyfish are abundant in the grass flats. These sea grasses have been threatened in the past by heavy sludge-like oil spills. Large grouper lurk in the deep rock-lined passes on the north end of the island. The largest variety of grouper is the goliath, which can reach a hundred pounds. A photograph taken in the early 1900s shows

A dolphin pod spotted between Egmont Key and Mullet Key. *Photo by author.*

a fisherman with one nearly the size of a grown man. Today, the goliath are protected. Egmont Key is also well known for the variety of sharks that frequent the north shipping channel. Old reports and photos describe twenty-foot hammerheads swimming in the channel, sometimes caught by fishermen after a long struggle.

During the spring and fall, mackerel, bonita and giant kingfish enter the bay through one of the two passes. During the cooler months, snook and sheepshead can be found under the docks on Egmont Key. The Coast Guard dock provides a good habitat, but the coal dock (now in disuse) may be the best, as it is close to the ninety-foot-deep northern channel.

Two aquatic mammals in the waters around Egmont Key are dolphins and manatees. Dolphins can be observed at any time of year as they surface in the Egmont shipping channel. They often dive in and out of boat wakes and travel in family groups called pods. The unusually cold winter of 2009–10 was especially stressful to both dolphins and manatees, and a dead dolphin washed up on the island.

Manatees are spotted less often around Egmont Key, but on June 19, 2010, a volunteer observed a mating herd of twelve manatees for several hours. A

sighting such as this is a once-in-a-lifetime event for most people. The lone female was pursued and wooed by eleven males. The female manatee is not sexually mature until five years of age and will mate with more than one male. After a year-long gestation period, she will produce a calf that she alone takes responsibility for raising. Females generally have a calf every two to five years.

A very rare sight around Egmont Key occurred in April 1962, when scores of local fishermen were stunned to see a humpback whale southwest of the island, near the whistler buoy. Observers estimated it to be about fifty-three feet long. Humpbacks generally travel from the Arctic to Antarctica and no one had ever seen one in the Gulf of Mexico before. The whale suddenly surfaced, shooting highly heated air twenty feet high through its blowhole. As the April 9, 1962 edition of the *St. Petersburg Times* reported, "The sight recalled the old Nantucket cry of 'Thar she blows!'"

An interesting and ancient creature that lives in the water off Egmont Key is the horseshoe crab. Biologists are interested in it because research on the crab's compound eye has led to better understanding of human vision. Horseshoe crab blood is useful in biomedicine, and the shell is used in the manufacture of such things as contact lenses and cosmetics. The Fish and Wildlife Research Institute has observed that horseshoe crabs spawn at high tide, just before or after the full or new moon. Horseshoe crabs or their shells can sometimes be spotted on Egmont Key's beaches.

Another seashore creature found in great numbers on Egmont Key is the ghost crab, a type of small sand crab aptly named due to its pale color, which provides perfect camouflage and makes it hard to spot on the beach. These two- to three-inch-long crabs are nocturnal. They build burrows at a 45-degree angle and about three to four feet down along the shoreline. The burrow entrance has a golf ball-sized hole that many visitors mistake for a snake hole. The "ghosties" use these burrows for hibernation during the winter, and they breathe by storing oxygen in sacs located near their gills during their six weeks of inactivity. They can run as fast as ten miles an hour and can quickly maneuver sideways, forward and backward. Ghost crabs' black eyestalks are retractable, and they have a 360-degree field of vision, although they can't see overhead, making them vulnerable to predators such as the yellow-crowned night heron, which considers them a favorite food. Ghost crabs eat a variety of things, including tiny insects, lizards and other crabs, but one of their favorite foods is newly hatched sea turtles. Curious beachgoers are well advised to refrain from sticking their hands down inside a ghost crab burrow; they may be small, but they can pinch hard!

Nesting Birds on Egmont Key

A staggering number of bird species come to Egmont Key to nest each year. In 1974, 392 acres of the island were designated as a National Wildlife Refuge under the supervision of the U.S. Department of the Interior. Egmont Key happens to be the only refuge island in Tampa Bay that is accessible by the public. However, if visitors wander south along the beach on either the Bay or Gulf side, they will encounter large signs reading, "Bird Sanctuary, Area Closed, Beach Closed." Farther north along the Gulf beach the Egmont Key Alliance has roped off sections where black skimmers and oystercatchers nest in colonies from March until September. The signs clearly state "Disturbance by humans or pets can cause nest abandonment and death of young birds," and "Flushing birds off nests exposes eggs and chicks to the sun and predators." Unlike nesting birds in northern climates, birds sit on their eggs here not to keep them warm but to keep them from the sun's harmful rays. Eggs left unprotected cook in the hot midday sun. It can be discouraging to read in publications like the Egmont Key Alliance's newsletter, *Egmont Key Notes*, reports from the rangers concerning bird disasters. For example, in 2002, the entire black skimmer colony was lost due to erosion and crow predation. On a more positive note, in June 2005, Barbara Schmidt reported,

A sign for the bird sanctuary warns off beachgoers. *Photo by author.*

A pair of royal terns on the Gulf shoreline. *Photo by author.*

Brown pelicans are one of the numerous species that nest on the island. *Photo by author.*

One of the last feral cats on Egmont Key. *Photo by author.*

"The baby brown pelicans, numbering about 1,000, are huge, and they are beginning to get their feathers and are shedding their down." By November, there were over 1,200 young pelicans, and less than a dozen were found that didn't survive. However, about 20 percent of the pelican nesting area was later destroyed by Hurricane Wilma, which impacted nesting the following

A pair of osprey have made their nest atop the remains of the plotting tower. *Photo by author.*

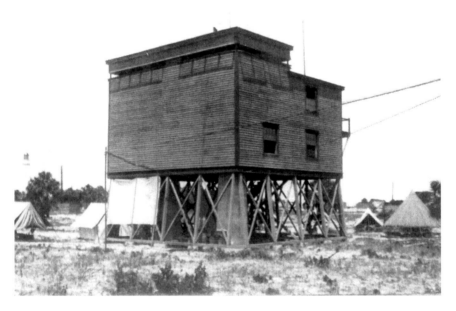

Plotting tower, circa early 1900s. The cement support pillars can still be seen. *Courtesy of Roberta Moore Cole.*

year. It would seem that raising young on the island, whether birds or turtles, can be a chancy thing given the whims of Mother Nature, but intervention and protection by the rangers and park volunteers helps the survival rate.

Another threat to nesting birds was carelessly brought about by humans, namely feral cats, possibly descendants of cats abandoned when Fort Dade was closed, or perhaps from the pilots' community. In the 1980s, these cats numbered about sixty. They wiped out the naturally occurring rabbits, raccoons, mice, bats and snakes. Today, there are no feral cats left on the island. However, should cats again populate Egmont Key, the wildlife would suffer, so families staying in the pilots' community today are no longer allowed to have cats.

The October 2009 issue of *Egmont Key Notes* describes saving a brown pelican that volunteers dubbed "Pelican Pete." Pete was found on the south beach, badly entangled in fishing line, complete with hooks and sinkers. This is not an uncommon fate for hungry pelicans who swoop down to snatch at a fisherman's bait. Most die, but Pete was lucky. He couldn't walk or fly, but rescuers were able to untangle him after dark using a flashlight. The next morning, Pelican Pete posed for a photo before flying off, apparently not too badly off in spite of his harrowing experience.

In addition to black skimmers and pelicans, other species found at Egmont Key include the American oystercatcher, royal tern, laughing gull, sandwich tern, osprey, snowy egret and mallard ducks. On the west shore of the island south of Battery McIntosh, a pair of ospreys have built a nest atop the pillars that once supported the plotting tower. The photograph on page 122 shows one parent sitting on the eggs and the other keeping watch.

Tom Watson, the assistant park manager, reported a very successful nesting year for 2010 with thousands of nestlings from a variety of species, including 600 pelican chicks, 650 white ibis, 3,200 royal terns, 2000 sandwich terns and 7,000 laughing gulls. Egmont Key was very fortunate to have had no ill effects from the 2010 oil spill in the Gulf of Mexico, and in fact, it received about a dozen brown pelicans and laughing gulls that had been rehabilitated and were relocated to Egmont Key for release.

Migratory birds also stop at Egmont Key in the fall and spring. Flocks of mottled ducks and occasionally geese can be seen taking a break from their long journeys. Birds of prey, such as the tiny sparrow hawk and endangered peregrine falcon, can sometimes be glimpsed in the Australian pines or sabal palms on the island.

VEGETATION ON EGMONT KEY

The plant life on Egmont Key includes almost a hundred different species. The most common are cabbage or sabal palms that cover much of the island, in spite of numerous fires whose ravages are noticeable on the trunks. Every year numerous palm trees fall on the Gulf side due to erosion and must be cleared from the beach.

One might expect to see thick mangroves, but they are nearly nonexistent on the eastern or landward side of Egmont Key, unlike most barrier islands. According to environmental biologist Dan Larremore, "Egmont is a unique place and that rule doesn't hold true. The eastern shore of Egmont receives a higher wave energy than the barrier islands, and mangroves have had a tougher time becoming established there. But they are there, if you look."

While mangroves aren't common on Egmont Key, just off its shores and barely visible only at very low tides, are vast sea grass beds that provide habitat for a huge variety of life: fish, crustaceans, shellfish, manatees and wading birds. Sea grasses are flowering plants, so they only can thrive in clear, shallow waters. Besides providing shelter for many species, the sea grass beds serve as a natural water filtration system and pump oxygen into the water.

Over a hundred years ago, the island had tall cedar trees and live oaks, as described by Major Francis Dade in a letter to his mother in 1834. Since then, however, loggers stripped the island of valuable timber, and the army also cut down trees for firewood. A few red cedars can still be found here and there, and the long needle pine has been reintroduced through the work of volunteers in recent years.

Phil Sorenson, a volunteer with the Egmont Key Alliance, was very knowledgeable about the plants that are common to Egmont Key today. On a walk around the island in the spring of 2011, he pointed out a variety of plants that are salt-tolerant and well suited to the dry conditions and sandy soil of Egmont Key. Sea oats grow along the shoreline, especially on the southern end near the pelican nesting area. Florida privet, a dense evergreen shrub that can reach ten feet in height, does well near the bay shore. In early spring, Florida privet produces small, greenish-yellow blossoms that attract many pollinators. Later, purplish-black berries form and are a favorite with island birds.

As mentioned previously, blue porter weed is an important food for gopher tortoises. This sprawling, semi-woody evergreen shrub is saltwater

Sabal, or cabbage, palms flank Fort Dade's brick roads. *Courtesy of Bert Mullins.*

tolerant and loves the warm temperatures of Egmont Key's summers. It grows rapidly to three or four feet in the summer, bearing tiny bluish flowers on slender stalks, and seemingly dies in the winter.

Coin vine, a climbing shrub that can grow to twenty-five feet long, is also native to the area and found on Egmont Key. Its flat, round, copper-colored fruit gives the plant its name. Traditionally, Native Americans used the crushed roots and bark of coin vine as a kind of sedative to stun fish in tidal pools, making them easier to catch.

Madagascar periwinkle (*Catharanthus roseus*) is a semi-woody evergreen found widely on the Gulf side of the island. It does well in Egmont's sandy, well-drained soil, producing rose pink flowers that bloom throughout the summer. Madagascar periwinkle has been used to treat diabetes, high blood pressure, asthma and other ailments. For over fifty years, it has been used to make a natural anticancer drug to treat leukemia, skin, breast and other cancers, as well as Hodgkins disease. However, biologists warn that Madagacar periwinkle is highly toxic if ingested or smoked, and it has been known to poison grazing animals.

The golden creeper (*Ernodea littoralis*) is very common in this area of coastal Florida. This small sprawling shrub has leaves clustered at the end

Madagascar periwinkle is common on Egmont Key. *Photo by author.*

of its stems and produces bunches of round, golden yellow berries, from which it gets its name. The berries are available most of the year, providing a valuable food source for birds.

Another plant that can be found on Egmont Key is smilax, also called cat briar or cat claw vine. It can be found climbing up the trunks of cabbage palms. There are many varieties of smilax, some of which are grown as ornamental ground cover in yards and are admired for their berries. All have heart-shaped leaves, and some types have sharp thorns resembling the claws of a cat. Some varieties are edible and are reported to taste like a nutty asparagus. The variety on Egmont Key is thorny and tends to be invasive toward other native plants if left alone.

Wax myrtle, also known as southern bayberry, is an evergreen shrub that can grow twenty feet high. The female plants produce pale blue berries in the spring but only if male plants are nearby for pollination. The light olive green leaves have a pleasant spicy aroma when crushed. Early settlers often boiled the berries to separate the waxy coating, which was skimmed off and used to make fragrant candles.

The strangler fig (*Ficus aurea*) is extremely common in South Florida and the West Indies. A continuous crop of seeds is produced in the fruit, and they are spread through bird droppings. A strangler fig starts when a sticky seed attaches to the bark of a host tree. Its life cycle is interesting and unusual, as it starts out as a parasite-like epiphyte or "air plant." The seed lodged in the host absorbs nutrients and water through air roots. Eventually these air roots grow downward to the ground and develop their own underground root system. Cabbage palms are typical hosts, but strangler figs will also grow on gumbo-limbo, slash pine, saw palmetto and live oak trees. The strangler fig is not a benign "houseguest" for its host, however, as it will entwine its roots and trunk around the host tree and "strangle" it to death by absorbing nutrients provided by the host tree. Many rodents, reptiles, bats, amphibians and birds make their homes in the hollow trunk that remains. In spite of its fatal attraction to the host tree, the strangler fig is considered a keystone tree in the ecosystem of South Florida. Besides providing habitat, it produces large amounts of figs, often a major source of food for wildlife during certain times of the year, so overall it is beneficial to Egmont Key.

Another unusual tree that can be found on Egmont Key north of the lighthouse is the Southern prickly ash, sometimes called the "toothache tree" or "tingle tongue tree" because the bark can produce numbness to the gums, mouth and tongue when the leaves or bark is chewed. Native Americans and early pioneers relied on the woods and fields for their pharmaceutical needs;

An example of a strangler fig living on a cabbage palm on Egmont Key. *Photo by author.*

Native American healers made poultices of the bark to treat sores and used the inner bark to make a soothing lotion. Both settlers and Native Americans used it for teething babies as well. The fruit of the tree provides food for birds on Egmont Key, so new trees tend to sprout below birds' favorite roosting places at the edge of woods.

Sea grapes grow all along the coast of this region and provide an important source of food for gopher tortoises and birds on Egmont Key. The fruit is edible for humans as well, and early settlers in particular made use of it for jams and jellies. The sea grape shrub has round leathery leaves that can measure as great as six inches in diameter, and the shrub itself can grow as high as thirty feet. It is well suited to the dry conditions and salt air on the island. The grape-like clusters of berries appear in midsummer, and when ripe, they change from green to reddish purple. Besides jam and jelly, the fruit can be used to make wine and can even be eaten raw.

Prickly pear cactus is also found on Egmont Key. The branches, or pads, and the reddish fruit are both edible, although the prickly spines must be carefully removed before cooking the pads. The plant uses its pads for photosynthesis, water storage and flower production. The juice is made into nectar and is commercially available. Some studies have shown the pectin contained in prickly pear pulp may help lower bad cholesterol and stabilize blood sugar. On Egmont Key, however, the prickly pear is a source of food for wildlife.

Egmont Key has native invasive species of plants, such as the aforementioned smilax, grapevine and coin vine. But in recent years, several nonnative invasive species have made their presence known on the island. One example is the tall Australian pine found on the north end. This salt-resistant "immigrant," not actually a true pine, is often planted along beaches in an attempt to halt erosion. It grows rapidly and creates thick, almost impenetrable groves that choke out native species. With the use of herbicides, it has been eradicated except for some that remain within the five-acre Tampa Bay Pilots compound.

Another invasive nuisance is the Brazilian pepper plant, which spreads rapidly and is difficult to eradicate, as its root system is widespread. The Brazilian pepper was originally brought into the area for use as an ornamental tree, as its attractive bright red berries form in the fall and winter. It was sometimes erroneously referred to as "Florida holly," despite not being related to the holly plant. Unfortunately, birds also love them and have spread the Brazilian pepper far and wide. For some years, the Egmont Key Alliance volunteers attempted to control Brazilian pepper by cutting

Egmont Key Alliance members remove Brazilian pepper and other invasive plants on the island. *Photo by author.*

and physically removing the plant, but it was a constant battle. Ecologists fear invasive species such as this one because, as native plants are edged out, it leaves the ecosystem vulnerable to disease or other disasters. In the spring of 2007, Wendy Anastasiou, a former officer of the Egmont Key Alliance, successfully obtained a grant to fund eradication of Brazilian pepper through the use of herbicide. The money came through the Environmental Protection Commission of Hillsborough County and was provided by the county's Pollution Recovery fund and federal funding. A massive one-stop effort with herbicide was what was needed to finally get this persistent threat to native species under control and stop it from shading out such plants as native grasses, sea grapes, saw palmettos and low-growing vegetation that provides food for the gopher tortoises. Rangers, environmental experts and volunteers are all making a difference in the survival of Egmont Key's wildlife and plant species, but the future always remains a challenge to overcome man's and nature's impacts on the environment.

EGMONT KEY TODAY AND ITS FUTURE

E gmont Key has had important historical and environmental significance, as seen in the previous chapters. Its location in Tampa Bay made it a stop-off point over the years for explorers, pirates, military, fishermen, sportsmen, boaters, tourists, sunbathers, birdwatchers and nature lovers. Today, visitors to the island may observe creatures as varied as sharks, crabs, dolphins, loggerhead turtles, the native gopher tortoise population and a wide variety of shore birds, from pelicans to laughing gulls. Many people enjoy swimming off the white sandy beaches or walking the trails. While the lack of commercial facilities on the island may be a detriment for some, the island's pristine, unspoiled beauty, as well as the magical feeling of being in a bygone era that it creates, appeals to most who venture here.

But has time stood still? Of course it hasn't, and Egmont Key faces continued challenges. It can only remain the way it is through the concerted efforts of a number of organizations and individuals working hard to preserve it. Many volunteer groups spend hours in cleanup and bird monitoring efforts: the National Audubon Society, Eckerd College, Rough Riders of Tampa Bay, Tampa Bay Pilots Association, the Egmont Key Alliance and various branches of the armed forces are some examples. Since the 1970s, the Marine Corps has been involved in cleanup efforts on the island, in connection with military maneuvers. The Marines typically practiced amphibious landings with reconnaissance planes directing them to simulated military targets and, on Sundays, worked to clean up the key by clearing trash and debris. In May 1988, a massive four-day cleanup project was initiated.

More than 600 volunteers and 28 local organizations collected 70 tons of litter from the island. On Friday, May 13, 1988, the U.S. military, including 100 members of the marines, army and National Guard staged a full-scale assault on Egmont Key to participate in the cleanup. The deputy director of Tampa's solid waste department described it as "one of the largest peacetime actions in the area since World War II." The following day, Boy Scouts and Girl Scouts came to the island to participate in the project.

Today, about 117 species of shorebirds are thriving within 97 acres set aside as bird nesting sanctuary areas on the south and east sides of the island, thanks to the joint efforts of the U.S. Fish and Wildlife Service, the Florida Fish and Wildlife Conservation Commission and volunteer groups, such as the Egmont Key Alliance. Beginning in the 1990s, the Egmont Key Alliance, a nonprofit volunteer organization, has come to the island the third Saturday of each month to carry on the cleanup and preservation of Egmont Key begun in 1988. Under the direction of the park ranger, a typical workday might see the group divided up to accomplish such tasks as clearing debris from the beach; removing palm fronds and trunks from the beach and trails; painting fences and crosses in the cemetery; sweeping sand and debris from the three-gun batteries; removing invasive plants and weeds (such as the Brazilian pepper and Australian pine); and fencing the bird nesting areas. The nesting areas are posted with signs prohibiting trespass and warning visitors that dogs are not allowed on the island due to the danger to nesting birds. During bird nesting season in the late spring, Alliance members also serve as bird stewards. In 2010, Egmont Key Alliance members collectively spent 10,000 hours in preserving the island's historic heritage, wildlife and habitat.

Another area of concern is the protection of the island's offshore sea grass beds, since it is vital for sustaining fish, shellfish and other sea life. It also serves as a natural filtration system and replenishes oxygen. The Tampa Bay area has lost much of its sea grass due to sewage disposal, storm water runoff and damage from boats. Protecting the sea grass is beneficial both ecologically and economically, as the loss of sea grass beds impacts fishing and water quality. The U.S. Fish and Wildlife Service has established an offshore sea grass protection zone to preserve this valuable resource.

Fire is an ever-present worry for the island. To minimize the negative impact of accidental fires either from human carelessness or natural lightning strikes, controlled burns are periodically conducted on the island. These eliminate the accumulation of dry palm fronds and other plant debris and remove nonnative grasses. On January 9, 2009, a controlled burn of

about sixty-five acres was held. Firebreaks cut across the island east to west successfully prevented the fire from spreading out of control. A second burn was planned for the following day but had to be cancelled due to strong winds. After the burn, new growth began to crop up, and the gopher tortoises that had taken refuge in their burrows reemerged. Cabbage palms, in spite of scorch marks on their trunks, continued to grow.

During the 1970s, F-4 fighter jets from MacDill Air Force Base in Tampa flew over Egmont Key on training missions. On May 11, 1972, a mid-air collision between two of these planes was reported in several local newspapers. One plane crashed into the Gulf, and the other, with a damaged wing, limped back to the base. The two pilots from the downed jet ejected into the water and were promptly rescued by a Coast Guard helicopter that fortunately was in the area, just ten miles away on a training mission. It picked up the jet's radio-radar beacon emergency signal and was at the site within minutes. The downed pilots were taken to the base hospital with injuries, but both survived. The two pilots from the damaged jet that returned to base were uninjured, and an Air Force spokesman commended them for "their remarkable feat of airmanship." An investigation of the cause of the collision was launched, as this had been the second such collision within a week, the previous one occurring near Avon Park. Two men fishing from the Rod and Reel Pier on the north end of Anna Maria Island were eyewitnesses to the accident, and fishermen in the Gulf reported seeing a bright orange flash followed by a mushroom-shaped cloud. Pieces of the flaming wreckage touched off several small brush fires on Egmont Key, according to some reports, and there was initially concern about explosions from the twenty millimeter practice rounds aboard the downed plane. The photo on page 134 shows the northern portion of Egmont Key near where the jets collided; the arrow indicates a plume of smoke from some of the jet's wreckage that landed on the island. Fortunately the fires did not cause much damage to the island, unlike the out-of-control fire in 1925 that destroyed the wooden structures of Fort Dade after it was decommissioned.

Ever since two gun batteries on the southern end of Egmont Key were lost in the Gulf of Mexico in the 1980s due to the destructive action of wind and tides, there has been renewed concern about beach erosion. In the late 1990s, Richard Davis, a geology professor at the University of South Florida in Tampa, found the bay side of Egmont Key was stable, but "the sand on the western side is being carried into the deep shipping channels north and south of Egmont and then out to sea by strong currents." In 2000, and again in 2006, the Army Corps of Engineers launched sand

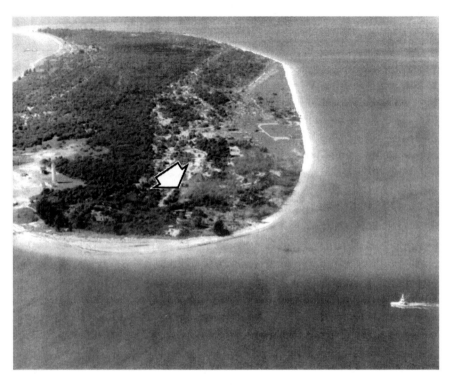

Aerial view of site where flaming debris from the mid-air fighter jet collision fell on Egmont Key. *Photo from author's collection.*

replenishment projects. In 2000, about 350,000 cubic yards of sugary-white sand was dredged from St. Petersburg harbor. Another 700,000 cubic yards of sand was replenished six years later. Richard Johnson, then president of the Egmont Key Alliance, said, "If it had not been done, these structures [existing gun batteries] would not have lasted through the winter."

The various governmental agencies and preservation groups involved with protecting the island seem to agree that sand replacement is a viable interim solution to erosion, but the sand replenishment done in 2000 was, unfortunately, washed away during the hurricane season. On average, hurricanes can be expected to make landfall in the Tampa Bay area once every twenty years. Since the last sand replenishment in 2006, the area has been lucky to have experienced few hurricanes. The increased width of the beaches following sand replacement has helped loggerhead turtles during their egg-laying season and also provided additional habitat for the birds. In turn, the nesting sea birds have helped prevent wind erosion, as

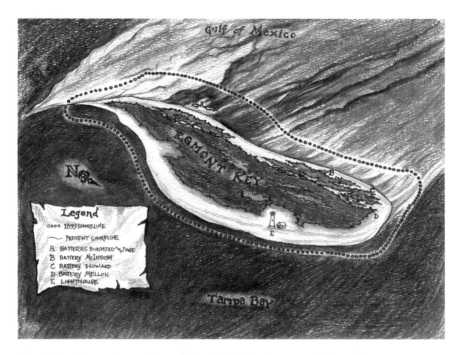

Sketch showing erosion on Egmont Key. *Original sketch courtesy of Andrew Thompson.*

their droppings encourage the growth of grasses, the roots of which hold the sand.

Currently the U.S. Army Corps of Engineers has tentatively scheduled dredging projects for 2013 that will generate about 45,000 cubic yards of sand to be placed off the Egmont Key shore in hopes that wave action carries some of it to the beach where it is needed. One of the projects is located near the Sunshine Skyway Bridge to widen the channel to accommodate extra large ships, such as the modern "fantasy-class" cruise ships calling at the Port of Tampa. Besides physical replenishment of sand, another plan from the 1990s called for seawalls to protect the gun batteries from erosion, but the Tampa Bay Regional Planning Council favored the installation of a sand-filled tube-like mesh, which was done instead. Until recently, these sand-filled tubes could still be seen on the northwest shoreline.

It is interesting to note some experts believe the size fluctuations of Egmont Key over hundreds of years is a natural process, depending on storms, winds and weather patterns. The U.S. Coast Guard and Geodetic Service did a survey of the island in 1875 and determined that it was 15–20 percent larger than the dimensions shown by Don Francisco Maria Celi in his 1757 survey.

Batteries Burchsted and Page are now underwater. *Photo from author's collection.*

The nineteenth-century survey noted the southwest shoreline had grown significantly. But about 100 years later, a survey done in the early 1980s found the island had been reduced to 398 acres, approximately the same size as the 1757 Spanish survey.

This ebb and flow of the island's size can be illustrated by the observations of Dennis Knight, the Egmont Key station manager for the Tampa Bay Pilots Association. When he first came to work on the island in 1970, he could drive a tractor on a wide beach around the front of Battery Burchsted. Ten years later, the gun battery was so close to the water a person could barely walk around it and would get his feet wet. In order to view what is left of the two southern gun batteries today, one needs scuba gear, as both batteries are underwater off the present shoreline.

The year 2005 marked the 100th anniversary of Theodore Roosevelt's executive order to establish nearby Passage Key as a protected Federal Bird Reservation. In the early part of the twentieth century, Passage Key was a 60-acre barrier island sheltering 102 species of birds. Today, Passage Key has all but disappeared, illustrating that erosion remains a major concern for the future of Egmont Key's presently thriving bird population. President Roosevelt's great-grandson, Mark Ames, a retired employee of the Vermont State Health Department, was a guest speaker at the celebration for the 100th

anniversary. He reminded the audience that Teddy Roosevelt established 55 wildlife preserves and that his foresight saved a window of time when a huge variety of wildlife, including birds, flourished along Florida's Gulf Coast.

The Egmont Key lighthouse was built to prevent ships from running aground during the mid-nineteenth century. Since then, the increased shipping traffic in and out of the main channel into Tampa Bay has occasionally presented problems for the island. In August 1993, three vessels collided. One freighter carried phosphate, one of the barges carried millions of gallons of aviation fuel and the other barge was loaded with heavy crude oil. The barge carrying jet fuel burst into flames, but the worst environmental damage was from the heavy crude oil leaking into Tampa Bay. Some of this oil washed up on the beaches of Mullet Key and Egmont Key, but most of it was fortunately carried out into the Gulf by prevailing winds and tides. The *Anna Maria Islander* reported, "The oil was spotted and cleaned from beaches on the northeast tip of Egmont Key...A bright yellow oil containment boom circled the island, protecting the wildlife from any contamination from the spill."

Most Americans are very familiar with the British Petroleum oil rig explosion that occurred off the Gulf Coast in the spring of 2010, now known as the largest oil spill in history. It had a devastating and direct impact on the environment and economy from Louisiana to Florida's Panhandle. Tourism in Tampa Bay suffered because vacationers stayed away, mistakenly thinking the oil had ruined area beaches. Egmont Key had a role in rehabilitating birds affected by the oil spill. About a dozen brown pelicans and laughing gulls were brought to the island to be cleaned and were released once they had recuperated.

Another challenge facing Egmont Key is its future status as a part of Florida's State Park system. Should Egmont Key not remain under the watchful eye of the park system with full-time rangers, it is feared wildlife would suffer, and the island's unspoiled beauty would deteriorate. Without the necessary full-time staff, the island could be closed to boaters during the week. Vandalism and just plain ignorance of the island's ecology and nesting birds could destroy what previous and present generations have worked so hard to preserve. With the state budget feeling the pinch during the recent economic downturn, there has been discussion of dropping the island's state park designation, and at one point, it looked like state funds to help beach sand replenishment were at risk. Both the Egmont Key Alliance and the Friends of the Tampa Bay National Wildlife Refuges support the continued beach replenishment, and after meeting with Manatee County officials,

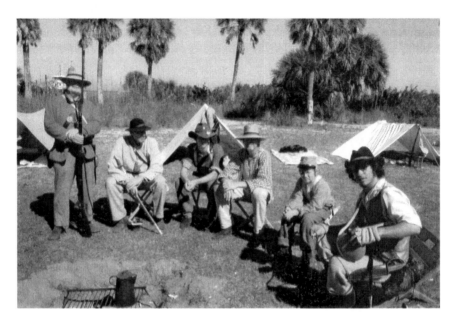

Civil War reenactors at the November 2011 Discover the Island event sponsored by the Egmont Key Alliance. *Photo by author.*

Florida governor Rick Scott reversed his decision to cut beach replenishment from the budget. The Egmont Key Alliance also is working to preserve the island's state park designation and is in contact with appropriate officials to help ensure the island will continue to be protected through state park status.

Each November around Veterans' Day, the Egmont Key Alliance holds a two-day weekend event for the public called Discover the Island. Its goal is to educate the public and showcase Egmont Key's unique features, history and wildlife. It is a family-oriented event with activities for children, reenactors from both Confederate army and Union marine units, displays and presentations by historians and groups such as the Audubon Society and Friends of the Tampa Bay National Wildlife Refuges, artists and a silent auction to raise funds for the Alliance's preservation projects. Visitors can take a self-guided tour along Fort Dade–era brick paths lined with palms. Volunteers at various sites highlight the history and significance of their station, such as the nerve center, where mines were set off when Fort Dade was active, and the location of the sunken Union tug, USS *Narcissus,* just north of the island offshore from Battery Mellon. At the 2011 event, visitors could tour a U.S Coast Guard cutter. From other volunteers, visitors learn about the plants, gopher tortoises and other wildlife. During this annual

event, children under the age of eleven can take the ferry from De Soto Park for free to encourage family attendance. As Egmont Key Alliance member Kathy Keleher put it, "Today's children are the people we will depend on in the future to preserve, restore, protect and defend Egmont Key."

BIBLIOGRAPHY

Ackerman, Sherri. "Seaworthy Schooling, Maritime Class Introduces Youngsters to Aging Industry." *Tampa Tribune*, November 17, 2011.

Addeo, Alicia, and Bart Moore. "Crossbows to Bombers: The Military History of Mullet Key." *Tampa Bay History* (Spring–Summer 1990).

Alder, June. "Egmont Key is Important Historical Site." *Islander*, September 18, 1986.

Armade, Charles. "The Tampa Bay Area from the Aborigines to the Spanish." *Tampa Bay History* (Spring–Summer 1979).

Baker, Bob. "Egmont Key." Transcript of Speech to Manatee County Historical Society. Manatee County Historical Society, Bradenton, FL. April 8, 1996.

Barker, Eirlys. "Tampa's Yellow Fever Epidemic of 1887–88." *Tampa Bay History* (Fall–Winter 1986).

Basnight, Bobby L. *What Ship is That: A Field Guide to Boats and Ships*. Guilford, CT: Lyons Press, 2008.

Bayles, Tom. "DEP: No Funds for Egmont Erosion Control, Preservationists Sought Money to Save 100-Year Old Fort Dade on the Fragile Island in Tampa Bay." *Sarasota Herald Tribune*, April 14, 1999.

Becnel, Thomas. "Island of Adventure—Egmont Key Offers Guided Tours as Part of its Weekend Festival." *Sarasota Herald Tribune*, November 10, 2007.

Bethell, John. *History of Pinellas Peninsula*. St. Petersburg, FL: Press of the Independent Job Department, 1914.

Bickel, Karl A. *Mangrove Coast: The Story of the West Coast of Florida.* 4th ed. New York: Coward-McCann, 1942. Reprint, Madison, WI: Omni Press, 1989.

Boyd, Mark. "The Seminole War: Its Background and Outset." *Florida Historical Quarterly* (July 1951).

Bradenton Herald. "AF Jets Collide Near Egmont Key." May 11, 1972.

———. "Closing Park Endangers Some Animals." November 30, 1992.

———. "Egmont Key Invaded." May 14, 1988.

Braidentown News. "Battleship Maine, Her Captain and the Disastrous and Terrific Explosion." February 25, 1898.

———. "War Situation." May 26, 1898.

Brown, Canter, Jr. "The Sarrazota or Runaway Negro Plantations: Tampa Bay's First Black Community, 1812–1821." *Tampa Bay History* (Fall–Winter 1990).

Brown, Robin C. *Florida's First People: 12,000 Years of Human History.* Sarasota, FL: Pineapple Press, 1994.

Buker, George E. *Blockaders, Refugees and Contrabands, Civil War on Florida's Gulf Coast, 1861–1865.* Tuscaloosa: University of Alabama Press, 1993.

Burger, B.W. "Tampa Bay Aboriginals from Contact to Extinction: Thoughts and Speculations." Paper presented at Florida Anthropological Society annual meeting, Jacksonville, FL, May 2000.

Canter, Mark. "Channel Pilots Plotting a Safe Course through Tampa Bay." *St. Petersburg Times,* July 24, 1988.

Chetlain, Kent. "Egmont Key—An Explorer's Paradise." *Islander,* September 17, 1981.

———. "Egmont Key Lighthouse 6th Brightest, First Built in 1848." *Islander,* 1975.

———. "Florida's Most Unusual Suicide Occurred on Egmont." *Islander,* 1975.

Clara Barton, Official National Park Handbook #110, Clara Barton National Historic Site, Maryland. Washington, DC: National Park Services, 1981.

Clarke, Christopher. "Egmont Key, Rich in History, It's a Welcome Haven for Visitors." *Bradenton Herald,* October 23, 1983.

Colbert, Sandy. "Shifting Sands." *Egmont Key Alliance Notes* (April 2002).

Cole, Roberta Moore. Transcript of Speech Given to Palmetto Women's Club. Personal collection of Roberta Moore Cole, March 19, 1986.

Covington, James W. "The Armed Occupation Act of 1842." *Florida Quarterly* (July 1961).

———. "Henry B. Plant, J. Lott Brown, and the South Florida State Fair." *Tampa Bay History* (Spring–Summer 1992).

————. "Seminoles Weren't Converted Easily." *Tampa Tribune*, May 10, 1992.

Degregory, Lane. "Who is Panfilode Narvaez? And Why Should We Care?" *St. Petersburg Times*, April 18, 2008.

Doubleday, Douglas. "Egmont Key Gets Power by Cable." *St. Petersburg Times*, April 6, 1963.

"Egmont Key Rich and Varied in its History." *Bulletin of the Peninsula Archaeological Society* (March–April 1966).

Erhart, Grace, and Irvin D Solomon. "Steamers, Tenders and Barks: The Union Blockade of South Florida." *Tampa Bay History* (Fall–Winter 1996).

"Erosion Jeopardizing Egmont Key." *Bay Sounding* (Winter 2011).

Evening Independent. "Mighty Dreadnoughts of the American Fleet Ordered to Mexican Waters." April 17, 1914.

Frye, Alexander. "Waiting for the War to Begin: News Dispatches from the Tampa Bay Hotel." *Sunland Tribune* 24 (1998).

Gaines, William. "The World War II Temporary Harbor Defenses of Tampa, 1942–1944." *Coastal Defense Journal* 17 (February 2003).

Gibson, Pamela N. and Ann Shank. "The Spanish-American War South of Tampa Bay." *Sunland Tribune* 24 (1998).

Grimes, David. "Fort Dade Proves Defenseless Against Forces of Time, Nature." *Sarasota Herald*, October 26, 1982.

Grismer, Karl. *A History of the City of Tampa and Tampa Bay Region of Florida.* St. Petersburg, FL: St. Petersburg Printing, 1950.

Hall, Howard. "Teacher May Have Been last Driver to Cross Bridge." *Bradenton Herald*, May 12, 1980.

Hanson, Jim. "Egmont Key Lighthouse Grounds for Sale." *Islander*, September 29, 1999.

Hawes, Leland. "Army Duty at Egmont Key in 1917 Wasn't Fun, Former Soldier Recalls." *Tampa Tribune*, April 3, 1988.

————. "Disease Plagued Fort During 2nd Seminole War." *Tampa Tribune*, December 4, 1988.

————. "Egmont Key Has Strategic Location." *Tampa Tribune*, July 12, 1987.

————. "Indians Fought Exile Near Tampa." *Tampa Tribune*, May 14, 1983.

————. "Outpost, Wartime Life on Egmont Key Thrilled Curious Young Girl." *Tampa Tribune*, July 19, 1987.

————. "Rare photos pop up in new brochure." *Tampa Tribune*, January 17, 1993.

————. "When Billy Bowlegs Toured the Big Apple." *Tampa Tribune*, July 15, 1990.

Hill, Judy. "Erosion leaving Egmont in Ruins." *Tampa Tribune*, October 18, 1987.

Horan, Kevin. "Explosions Mark end of Fort." *Bradenton Herald*, May 25, 1999.

———. "Leaders Seek Egmont Help." *Bradenton Herald*, January 30, 1999.

———. "Project Repairs Erosion Damage." *Bradenton Herald*, March 7, 2001.

———. "Volunteers to help clean Egmont Key." *Bradenton Herald*, May 11, 1999.

Hudson, L. Frank. "Egmont Key, A Jewel of History." *Bulletin of the Peninsular Archaeological Society* 3 (September 1968).

Huettel, Steve. "Bay Pilots get 6% Pay Hike." *St. Petersburg Times*, November 21, 2008.

Hurley, Neil and Geoffrey Mohlman. *Lighthouses of Egmont Key*. St. Petersburg, FL: Historic Lighthouse Publishers, 2002. CD-ROM.

Islander. "Four Centuries of History are Buried on Egmont Key." February 16, 1967.

———. "Lost Giants." November 23, 1979.

Jarvis, Eric. "The Florida Land Boom, Tourism, and the 1926 Smallpox Epidemic in Tampa and Miami." *Florida Historical Quarterly* (Winter 2011).

Keleher, Kathy. "Discover the Island Weekend." *Egmont Key Notes* (January 2011).

Kennedy, Sara. "Dredging Project to Begin in March." *Bradenton Herald*, February 16, 2012.

Kerr, Captain G.E. "Influenza and Pneumonia Epidemic at Fort Dade, Egmont Key." Report to Surgeon General, Headquarters of Coastal Defenses of Tampa, November 9, 1918.

Kirkham, Cecil E. "Egmont Key in '43–A Wartime Remembrance." Unpublished memoir. Egmont Key Collection, Pass-a-Grille, Florida, Gulf Beaches Museum Archives.

Knetsch, Joe. *Florida's Seminole Wars, 1817–1858*. Charleston, SC: Arcadia Publishing, 2003.

Knowles, G. B. "Escape to a Desert Island—Right in your Own Backyard." *Islander*, June 30, 1983.

———. "Isolated Egmont is Rich in History, Legend, Fish and Wildlife." *Islander*, June 8, 1978.

Koff, Stephen. "Egmont Key Might Become State Park." *St. Petersburg Times*, July 6, 1988.

Kohlman, Betty. "Follow the Brick Roads on Egmont Key and Find an Island's History." *Bradenton Herald*, November 29, 1982.

Landry, Sue. "Eckerd Students Uncover Egmont's Past." *St. Petersburg Times*, November 1, 1993.

Lane, Cindy. "Discover Egmont Key." *Anna Maria Sun*, November 16, 2011.

———. "Egmont Funding Jeopardized." *Anna Maria Sun*, April 6, 2011.

———. "Egmont Passage Plans to Be Revised." *Anna Maria Sun*, March 26, 2006.

———. "Lighthouse Treasures to Be Restored." *Anna Maria Sun*, April 20, 2011.

Laumer, Frank. "This Was Fort Dade." *Florida Historical Quarterly* (July 1966).

Levy, Art. "The Island that's Loved Too Much." *Sarasota Herald Tribune*, July 10, 1994.

Linnard, Thomas B. "Memoir to Accompany Map of Military Operations in Florida." Dade City, FL: Seminole Wars Foundation, 2007.

Manatee River Journal. "Eight Selects Go to Fort Dade Next Tuesday." October 17, 1918.

———. "Fort Dade Defeated the High School Boys in a Hard-fought Game." December 14, 1911.

———. "Hot Games of Ball Thursday." August 18,1910.

———. "Moving Pictures and Band Concert Tonight." August 18, 1910.

Mannix, Vin. "Refuge Milestone Honors Roosevelt." *Bradenton Herald*, October 11, 2005.

Mapping of the Fort Dade Historic Transportation Network, Egmont Key, Hillsborough County, Florida vol 1, Final. Tampa, FL: Pan American Consultants, June 2007.

Marston, Red. "German Sub Holds Secrets." *St. Petersburg Times*, April 19, 1963.

———. "Our Biggest Tourist Shows Up, a Whale Takes a Look-See Around." *St. Petersburg Times*, April 19, 1962.

Matthews, Janet. Interview with Captain John Birdsall. Egmont Key, May 29, 1976. Transcript. Archives of Gulf Beaches History Museum, Pass-a-Grille, FL.

McDuffee, Lillie B. *The Lures of Manatee*. 2nd ed. Atlanta, Georgia: Foote and Davies, 1961.

McKay, D.B. "Genial Lighthouse Keeper Entertained Many Old Timers or Egmont Excursions." 1951. Egmont Key archive file, Holmes Beach, FL: Anna Maria Public Library.

McNeill, Megan. "Uncertain Future, A Visit to Egmont Key." *Bradenton Herald*, December 20, 1992.

Miller, Jean. "They Were Stationed in Paradise." *St. Petersburg Times*, August 29, 1991.

Mohlman, Geoffrey. "An Island Fortress: Egmont Key's Fort Dade." *Tampa Bay History* (Spring–Summer 1980).

Moore, Roger. "Close Encounters with Egmont Key." *Bradenton Herald*, October 11, 2005.

Moran, Kevin. "Explosions Mark End of Fort." *Bradenton Herald*, May 25, 1999.

Morelli, Keith. "Long-lost Ship May Surrender Civil War Secrets." Tampa Bay Online, May 22, 2008. http://www2.tbo.com. Accessed November 30, 2011.

Morgan, Philip. "Egmont Key Lighthouse." *Tampa Tribune*, July 6, 1998.

Mormino, Gary. "Tampa's Splendid Little War, a Photo Essay." *Tampa Bay History* (Fall–Winter 1982).

Morning Tribune. "At Port Tampa, Government Transports Continue to Come—Three Yesterday and Three Today." May 22, 1898.

———. "Gay Sunday, Yesterday Was a Red-Letter Day for Tampa." May 16, 1898.

———. "*Maine* Was Blown Up By a Floating Mine." March 27, 1898.

———. "Many Americans Came on *Mascotte*." April 1, 1898.

———. "Tampa Bay Hotel Taken." April 22, 1898.

———. "Wade to Win, Tampa will be the Point of Departure of the Troops." April 29, 1898.

Morris, John W. "Florida Aquarium Discovers Confederate Blockade Runner." *Zoo and Aquarium Visitor* online newsletter, May 22, 2008. http://www.zandavisitor.com/newsarticle_116_Florida_Acquarium.

Morris, Theodore. *Florida's Lost Tribes*. Gainesville: University Press of Florida, 2004.

Neff, Lisa. "Sea Turtle Nesting Season on Island Horizon." *Islander*, April 20, 2011.

North, Don. "Egmont Key: Seaworthy Sentry of the Ship Channels." *Floridian*, July 13, 1969.

North River News. "Gopher Tortoise Program to Be Presented November 15 by Manatee County Audubon Society." November 8–14, 2007.

Norwood, Carolyne. "Roberta Cole Remembers, Growing up on Egmont was Paradise." *Islander*, April 24, 1986.

Ohr, Tim. "Egmont Overture, the Siren Song of Lonely, Lovely Egmont Key." *Sarasota Magazine* (Summer 2003).

Perry, I. Mac. *Indian Mounds*. St. Petersburg: Great Outdoors Publishing, 1993.

Pittman, Craig. "Dead Dolphins, Turtles Still Washing Ashore." *St. Petersburg Times*, April 8, 2011.

———. "Egmont Key's Lighthouse, 55 acres put up for sale." *St. Petersburg Times*, November 13, 1999.

Pizzo, Tony. "Fort Brooke: The First Ten Years." *Sunland Tribune* 4 (November 1988).

Porter, Kenneth. "Billy Bowlegs (Holata Micco) in the Seminole Wars, Part I." *Florida History Quarterly* (January 1967).

Port Manatee, The Right Turn on Tampa Bay. Palmetto, Florida. Manatee County Port Authority. 2011. Official Directory of the Manatee County Port Authority.

Prouty, Ronald. "War Comes to Tampa Bay: The Civil War Diary of Robert Watson." *Tampa Bay History* (Fall–Winter 1988).

Rackleff, Bob. "Florida Was Third to Secede." *St. Petersburg Times,* January 9, 2011.

Rahini, Shadi. "Constant Erosion Eats Away Egmont." *St. Petersburg Times,* June 2, 2006.

Reddick, Dick. "Fort Dade, Egmont Key, Florida." *The Sundial, the Sunshine Postcard Club Newsletter* (January 2011).

Rich, Jennifer. "Meeting Port Manatee's Director of International Sales." *Bradenton Herald,* March 7, 2011.

Roat, Paul. "Spill Spares Island Beaches." *Anna Maria Islander,* August 19, 1993.

Rupert, Cynthia. "A Day in the Life of a Tampa Bay Pilot." *Bradenton Herald,* February 15, 1993.

Russell, Pam Radtke. "Boaters Must Back Off, Egmont Key Bird Refuge Enlarged." *Bradenton Herald,* July 19, 1996.

Sanders, Katie. "State Proposes cutting Egmont Key Funding." *Bradenton Herald,* March 25, 2011.

Schmidt, Barbara. "Baby Brown Pelicans." *Egmont Key Notes* (June 2005).

"Sea Turtle Monitoring Project Begins 6th Year." *Egmont Key Notes* (June 2005).

"Shadows of History." Supplement. *Island* and *Banner,* November 23, 1978.

Shyr, Luna. "A Test made from the Blood of Horseshoe Crabs Just Might Have Saved Your Life." *National Geographic Magazine* (August 2011).

Smith, E.A. "When Steamboats Left Tampa Bay." *Tampa Bay History,* May 5, 1980.

Smith, Grady, Jr. "Florida Seminoles Survive." *Yesterday in Florida* (Spring 2005).

Smyth, G. Hutchinson. *The Life of Henry Bradley Plant.* New York: G.P. Putnam & Sons, 1898.

Sprague, John T. *Origin, Progress and Conclusion of the Florida War.* New York: Appleton & Company, 1848.

Stafford, John W. "Sentinel of Tampa Bay." *Tampa Bay History* (Spring–Summer 1980).

Starnes, Sam. "Freighter, Barges Collide; Oil Spill Spreads 10 Miles." *Bradenton Herald*, August 8, 1993.

Stinemetz, Morgan. "Historical Key Lighthouse Casts Its Beam for Visitors." *Sarasota Herald Tribune*, July 18, 1990.

———. "Island Stockade Held Captive Indians." *Sarasota Herald Tribune*, December 30, 1998.

———. "The Pilots of Tampa Bay, When You Do This Every Day It Is A Routine Thing." *Manatee Magazine* (January 2, 1983).

———. "Union Sympathizers Hid on Egmont Key." *Sarasota Herald Tribune*, January 6, 1999.

Stober, Dan. " 'Slow News Day' Turns to Bedlam." *Bradenton Herald*, May 11, 1980.

St. Petersburg Times. "Egmont Key is Swept by Flames, Big Fire is Aftermath to Federal Raid." April 25, 1925.

———. "Marine Corps Plans Egmont Key Invasion." April 15, 1977.

———. "2 MacDill Planes Collide Over Gulf; 4 Elude Death." May 12, 1972.

Strickland, Alice. "Blockade Runners." *Florida Historical Quarterly* (October 1957).

Tebeau, Charlton W., and William Marina. *A History of Florida*. Coral Gables, FL: University of Miami Press, 1999.

Thompson, Donald. Interview with John McDonald on commercial fishing, 1939–1948, April 2011.

Thompson, Stephen. "Shipwreck near Fort De Soto may receive state designation." Tampa Bay Online, October 28, 2010. http://www2.tbo.com/news.

Tillman, Jodie. "A Chance to Preserve History–Underwater Shipwreck off Egmont Key." *Tampa Bay Times*, January 5, 2012.

U.S. Department of Interior, Fish and Wildlife Service. *Tampa Bay Refuges, A Comprehensive Conservation Plan*. Crystal River, FL: Government Printing Office, May 2010.

Ware, John D. "Biographical Sketch of Charles Mortimer Moore, Done From Two Interviews When He Was 90 Years Old." Tampa Bay Pilots. Tampa, FL, 1966.

———. "Pilots and Piloting on Tampa Bay." FloridaMaritime.org., September 11, 2010. http://floridamaritime.org/pilots-and-piloting-on-tampa-bay/. Accessed Novmber 17, 2011.

————. "Tampa Bay in 1757: Francisco Maria Celi's Journal and Logbook, Part I." *Florida Historical Quarterly* (October 1971).

Warner, Joe, and Libby Warner. *The Singing River: A History of the People, Places and Events Along the Manatee River*. Bradenton, FL: Printing Professionals & Publishers, 1986.

Warner, Libby. Interview with Carlos Cambell. Transcript. Egmont Key Collection. Eaton Room Historical Archives, Manatee County Central Library.

Watson, Tom. "Egmont Key's Wildlife Report." *Egmont Key Notes* (January 2011).

Whisenant, Blake. "Treatise on Manatee River." Transcript of Speech Given to the Manatee Historical Society. Manatee Historical Society, Bradenton, FL. February 16, 2000.

Whitford, Nancy. "Ghosties, or Ghost Crabs of Egmont Key." *Egmont Key Notes* (May 2011).

Wiggins, Jim. *Manatee County: Images of America*. Charleston, SC: Arcadia Press, 2007.

Wolff, Christine. "Skyway Death Toll Hits 32, Vehicles Tumble 15 Stories." *Bradenton Herald*, May 10, 1980.

Wozniak, Lara. "Nation Averages 27 Oil Spills Daily." *Bradenton Herald*, March 20, 1990.

Wynne, Nick, and Richard Moorhead. *Florida in World War II, Floating Fortress*. Charleston SC: The History Press, 2010.

INDEX

ABOUT THE AUTHORS

Don Thompson is a retired high school social studies teacher who taught in Michigan, Vermont and the Syracuse, New York area. Since retiring, he has worked as a historical interpreter and has done first-person interpretations of historical figures, such as Samuel de Champlain, Henry Hudson, Florida railroad baron Henry B. Plant and philanthropist Andrew Carnegie, for schools and historical and civic groups. He has authored four previous books: *The Golden Age of Onondaga Lake Resorts, Seeking the Northwest Passage, Lake Bomoseen: the Story of Vermont's Largest Little-Known Lake* and *Castleton Vermont: Its Industries, Enterprises and Eateries*. Don's family has owned a home on Lake Bomoseen in Castleton, Vermont, since 1967, and while he and his wife are residents of Parrish, Florida, they still spend summers at Lake Bomoseen. He is a member of the Egmont Key Alliance, a volunteer organization that promotes and preserves the island's history, wildlife and plants. He has recently developed a slide program on Egmont Key covering topics from Native Americans to the building of Fort Dade and the present-day birds, plants and animals on the island.

C arol Thompson is a retired fifth-grade elementary teacher who shares her husband's interest in history. She coauthored *Seeking the Northwest Passage* with him in 2008. She has been interested in writing for many years and, in addition to working on two published local history books, has recently completed a forthcoming juvenile novel.

Visit us at
www.historypress.net